IMAGES
of America

ST. CLOUD

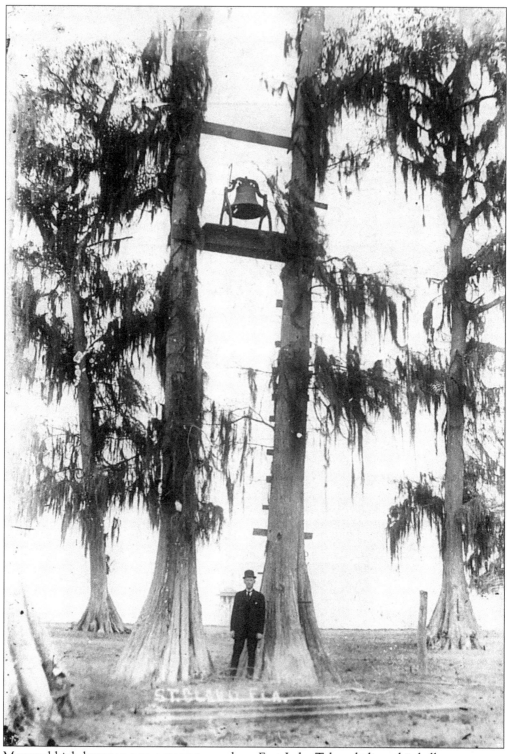

Mounted high between two cypress trees along East Lake Tohopekaliga, this bell was rung to sound the beginning and ending of the workday at the St. Cloud sugarcane plantation and mill.

IMAGES
of America

ST. CLOUD

Jim Robison and Robert A. Fisk

ARCADIA
PUBLISHING

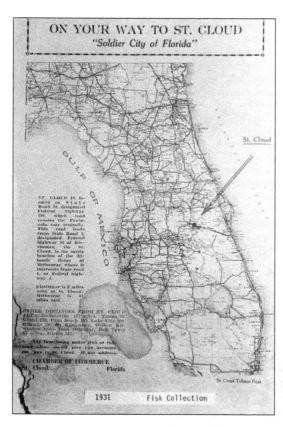

Lake Tohopekaliga and the low lands known as Cross Prairie separate St. Cloud from Kissimmee and the rest of western Osceola County. Despite massive dredging, including the digging of the St. Cloud Canal linking Toho and East Lake Tohopekaliga in the late 1800s, as well as tremendous population gains in recent years, St. Cloud, founded as a veterans' colony, remains a separate political and economic community from the larger city of Kissimmee, home of the county seat.

CONTENTS

ACKNOWLEDGMENTS

Jim Robison would like to thank Bob Fisk for the generous gifts of his time and counsel that made possible this photographic history of St. Cloud. Fisk also selected St. Cloud Main Street to receive profits from the book's sales. With his assistance, St. Cloud Main Street can continue its effort to preserve the city's heritage and promote its future. Generations to come will thank Fisk for preserving and archiving the largest collection of old photographs of St. Cloud. The authors also would like to acknowledge the many organizations, families, and individuals whose photographs have become part of the Fisk Collection. Special thanks are extended to the Osceola County Historical Society and the St. Cloud greater Osceola County Chamber of Commerce. Family and individual photographs came from Abbie Roberts, T.C. Roberts, John Crawford, Myrtle Barnes, the Kempher family, Donna Zeller Kelly Thompson, R.U. Zimmerman, David Snedeker, the Billy Newman family, Thomas Brooks, and others. A special thanks is extended to Robyn Robison for layout assistance and her cheerful encouragement during the months her living room and dining room became a research and display area, and to Alma G. Fisk for the years she put up with photo-making messes in her home.

INTRODUCTION

St. Cloud has a common frontier settlement history with Volusia, Orange, Lake, Brevard, and Seminole Counties, which make up the metro Orlando area. The 1850 census, taken five years after Florida became a state, found only about 450 settlers living in the interior wilderness of what today is Central Florida. These were the closing years of the United States Army's nearly 40-year campaign to rid Florida of Seminoles. During the war years, the largest towns were along the coast. Seminoles and black allies fled to the wilderness interior, using the backcountry along the St. Johns River to elude the army. They found safety in the wilderness of Florida's interior near Reedy Creek, Lake Tohopekaliga, and the Kissimmee River. They raised herds of Spanish-era scrub cattle, and their black allies taught them to farm. Just west of the area that would become St. Cloud, an island in Lake Tohopekaliga was the sanctuary selected by Emathla, or King Philip, a powerful Seminole chief who had led raids against planters in Florida in the early 1800s. The Seminoles called the lake Tohopekaliga or "fort site" because its thick foliage provided protection for their stockade-like settlements. The island was the birthplace of King Philip's son, Coacoochee, a fierce warrior also known as Wildcat, whose 1837 attack on a Lake Monroe army camp took the life of Capt. Charles Mellon. The settlement of Mellonville on the site of the old fort would become the region's largest trading area during sporadic skirmishes between settlers and Seminoles that kept federal soldiers stationed throughout the state until 1858. During the lull in fighting between the last of three Seminole Wars and the outbreak of the Civil War, more than 6,000 homesteaders filed claims. After the South surrendered to the Grand Army of the Republic, the state's population blossomed. Riverboats and, later, railroads brought Northern travelers to the winter resorts and settlers gobbled up land along the St. Johns River for citrus groves and vegetable farms. Land speculators drained the Kissimmee River Valley for sprawling cattle ranches and homesteads. The legislature created Osceola County in 1887 by slicing off parts of Brevard and Orange Counties. Hamilton Disston, heir to his father's Philadelphia saw-manufacturing company, made a deal with the cash-starved state of Florida in the 1880s to drain swamps and dredge a river highway from Lake Tohopekaliga to Fort Myers on the gulf. That opened Florida's vast interior for farms, railroads, and real estate development. On muck land that just two years earlier was cypress swamp and saw grass along East Tohopekaliga, Disston's Florida Sugar Manufacturing Co. planted 1,000 acres of sugarcane. Disston's sugar mill on the St. Cloud Canal produced thousands of barrels of sugar hauled to Kissimmee on the Sugar Belt Railroad. His land-sales campaigns reached throughout the United States and Europe, but bad weather in Florida and the failing national economy of the mid-1890s doomed Disston. After the Spanish-American War ended, veteran pensions founded a city at what had been the St. Cloud plantation and its mill on the southern shores of East Lake Tohopekaliga. An engineer among

the many Frenchmen who came from Louisiana to work at the plantation had suggested the name St. Cloud after a Paris suburb. The name stuck when the Grand Army of the Republic Association and its Washington-based newspaper made the plantation land home to the largest concentration of Union Army veterans in the south, second only to Chicago in the nation. The association organized a land company that in 1909 bought the defunct sugar plantation. Its newspaper, the *National Tribune*, advertised city lots, nearby farmland, and a "climate with no extremes" to lure military veterans looking for a warm retirement community. Veterans— including Spanish-American War soldiers who first saw Florida from railroad cars taking them to a Tampa staging area for troops that were to be shipped off for the war in Cuba—bought the first 100 lots for $50 each. With each lot, the land company gave veterans five acres near the city. St. Cloud adopted the slogan, "The Friendly Soldier City." The community near the old Sunnyside Railroad Station had dwindled to about 20 people and a handful of homes after the demise of the sugar plantation in the 1890s. Soon though, 2,000 new residents arrived, and they would soon have their own city hall, newspaper, power plant, waterworks, post office, hotel, drugstore, doctor's office, hardware store, bank, churches, and dozens of businesses. The timing was perfect. The sugar plantation folded because of the after effects of two bitter back-to-back freezes, speculation in Florida land, and a nationwide depression. The plantation had been abandoned for a decade when Florida again began enjoying one of its land booms. A year after the first newspaper promotion called St. Cloud a veteran's paradise on "a beautiful sheet of water," old soldiers had moved into about 400 homes. The Washington office of the veterans' association issued 4,000 land deeds in 1909. Veterans arrived faster than homes could be built, so tent cities popped up. The October 14, 1909 issue of the *St. Cloud Tribune* (named for the association's newspaper) reported that the hotel in St. Cloud had been overflowing with guests since it opened a week earlier. The executive board of the veterans association ran the fledgling community until the state legislature approved a city charter using the name from the old sugar plantation—a suggestion some believe was made by a principal at Kissimmee High School—on February 20, 1911.

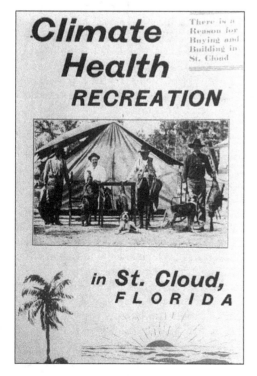

Shown here are four St. Cloud veterans proudly displaying trophy-size Osceola turkeys after a day of hunting in the wilds. The tents were set up in the early 1900s before the first houses were built. This photo was used in the early 1930s for an advertisement promoting St. Cloud.

One

HOMESTEADING THE
LAND OF THE SEMINOLES

The first people to live among the cypress swamps, oak hammocks, and the pine and palmetto forests east of Lake Tohopekaliga and south of East Lake Tohopekaliga were members of ancient tribes who followed the St. Johns River inland from the coast. Horses, cattle, and hogs, brought to the Florida shores by the Spanish, escaped to live wild in the swamps and flatlands. Members of Southeastern tribes and runaway plantation slaves seeking sanctuary migrated south along the river to become the Seminoles, from Creek and Spanish words for people who live in the wild. In May 1858 the steamer Grey Cloud docked at the mouth of Tampa Bay. Billy Bowlegs, the last of the Seminole chiefs to resist the army, boarded for their trip to Arkansas. Many other Seminoles remained in Florida, showing military road builders the best sites for bridges over rivers and guiding them through unmapped wilderness. Seminoles were often guests in the homes of early settlers.

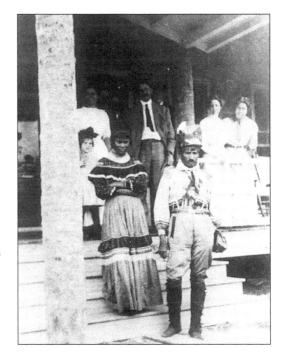

Hunting guide Cofeehatco, or Billy Bowlegs III, nephew of the famous chief with the same name, is shown here on the steps of the home of Minnie Moore-Willson, who helped establish the first Seminole reservation in Florida. Billy Bowlegs II was 113 years old when he died in 1965.

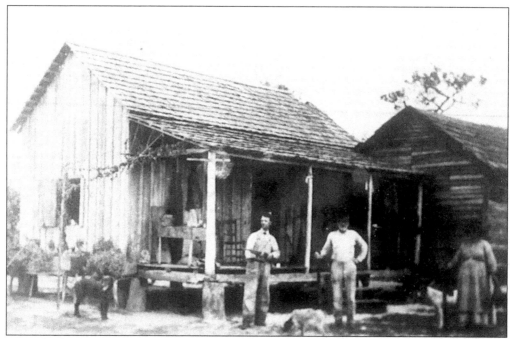

From the late 1860s through the 1870s—a time Florida historians have called the "seedling years"—pioneer families provided for themselves or did without. The Savage family, shown here at their Cracker-style house on Savage Creek, ran one of the early trading posts.

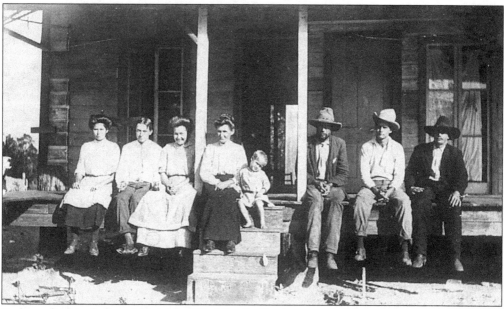

Early settlers, including this unidentified family, lived in simple homes built from pine lumber that they themselves cut and roofing shingles from split cypresses. Many were former Union and Confederate soldiers who had loaded families and belongings onto two-wheeled carts and headed south to grub out a life among the palmettos, pine forests, and cypress swamps.

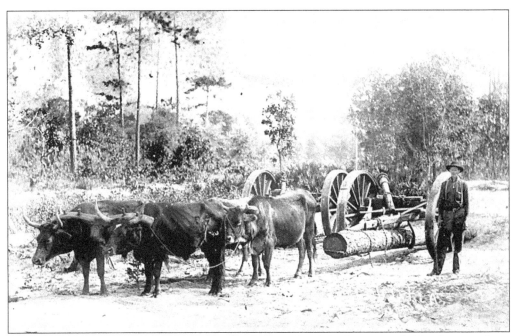

Early Florida farmers used horses and mules, but much of the heavy work like dragging logs, clearing land for plowing and planting, and hauling crops and cargo were left for teams of oxen.

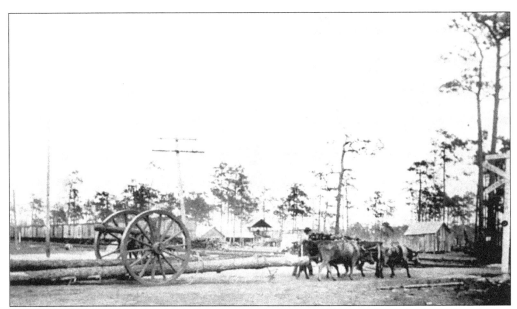

Oxen were less susceptible to Florida's diseases and better able to endure the heat than horses and mules. A team of oxen also cost less than a single horse and ate less. An ox is a steer—meaning that they have been castrated. Those bright enough to learn to respond to spoken commands lived to be 15 or 16 years old, long after most steers were butchered.

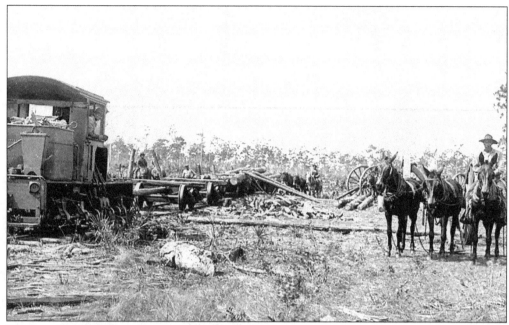

The post-Civil War generation carried with them their father's trades. Those skilled with lumber and woodworking found odd jobs to save money for homesteads. These men are cutting pine lumber at a steam-powered mill that used scrap wood for fuel.

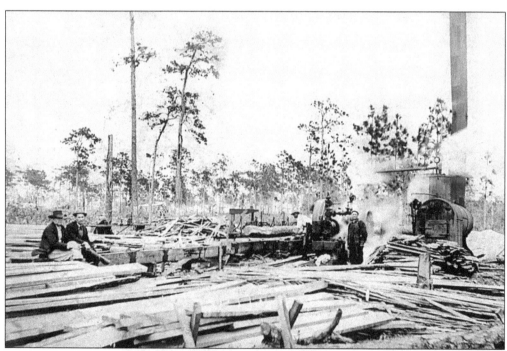

Cut logs were hauled out of the pine forest on the flatbeds of early railroads. Many men hired out to clear land for citrus trees, then stayed on to plant trees and learn to be citrus growers and nurserymen. Others signed on for scrub-cattle roundups.

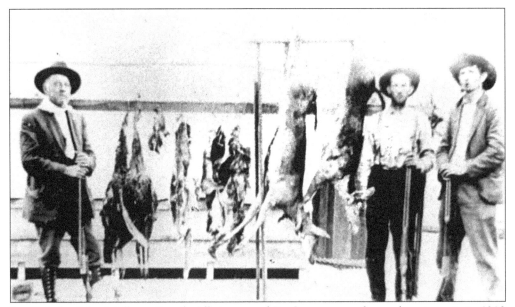

Jim Oglesby, John Mallone, Enoch Albritton, and Jim Long return from a hunting trip in 1909 with wild turkeys, deer, and other game. Early hunters tramped through the swamps and dense forest to trap game birds for their plumes and to hunt alligator, bear, and deer. At the trading posts at steamer wharfs, they exchanged the meat, hides, and plumes for hardware of other goods that they could not make themselves.

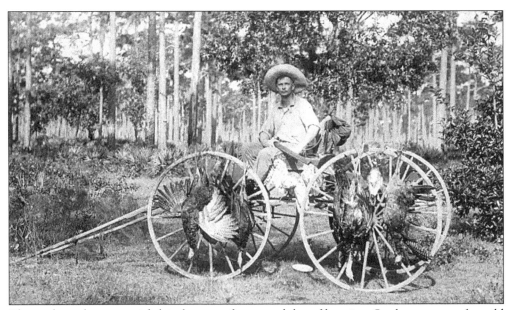

This early settler poses with his shotgun after a good day of hunting. Settlers set traps for wild turkeys, which traveled in large groups. Several at a time could be lured into large pens with covers by baiting a trench into the pen with food.

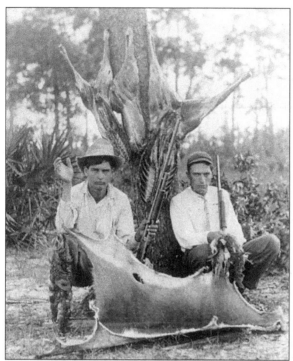

The wilds of the St. Johns and Kissimmee Rivers were overflowing with game, fish, and birds. Hunting crane, egret, and other wading birds provided a livelihood, as European designers of women's hats paid a high price for Florida plumes. New York millinery shops fastened plumes and, sometimes, whole birds on women's hats. When prostitutes started wearing feathered hats, refined ladies shunned plumes.

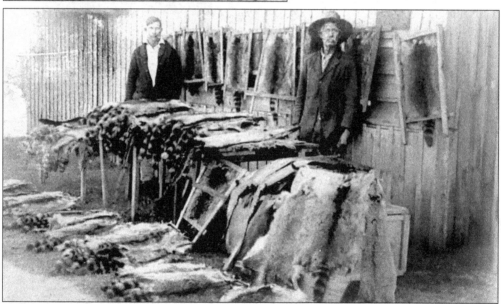

Hiram Padgett and Jim Peterson, shown with raccoon skins, made their living at a time when homesteaders' lives were a matter of survival. Most families cleared their own land and grew their own rice, corn, and sweet potatoes. They planted beans next to the corn, so the vines would climb the stalks; they planted squash between rows. Whiskey was distilled from corn mash. Struggling families planted sweet potatoes and corn for their tables and a little cotton for a cash crop. They bought a cow to provide milk and butter for the family, and they preserved game meat and fish with salt. Some settlers even made their own Cracker flour by digging up the roots of coontie, a palm-like shrub.

Anna Kiehl stands between William Abby and Charles Lowe, holding their catch of the day. Shorty Lowe is shown in front. Fish and meats that were not eaten right away could be preserved in layers of salt or a salt-molasses mixture. Some families covered the meat with a brine solution, sometimes flavoring the brine with ale or spices. The meat would be scrubbed and soaked to wash out the salt and restore its moisture before cooking.

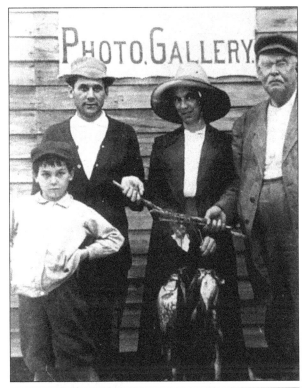

On hunting and camping trips, settlers, such as these in the late 1800s, could enjoyed the bounty Florida offered—plentiful cattle, quail, duck, wild turkey, deer, boar, and fish from the rivers and coast. Some families stored salted pork, beef, venison, fish, and rabbit in barrels, sealing out air with layers of lard. Jerky of venison and beef was made by putting the meat in salt or brine for several days, then hanging strips of the meat on poles or the kitchen roof to dry in the sun.

15

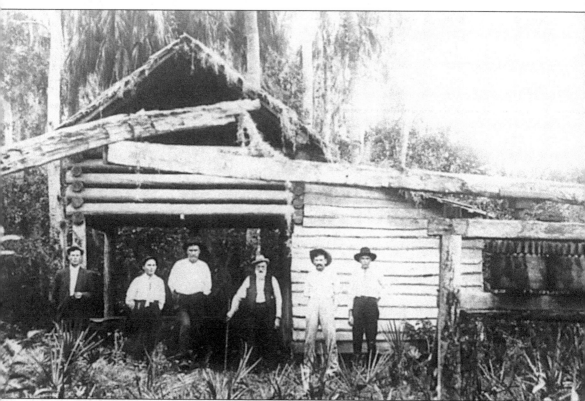

At Wolf Creek, also named Savage Creek on some early maps, the Savage family built this sugarhouse in the late 1800s north of Deer Park. The Savage family trading post thrived during the steamer days. Sometimes Brevard County commissioners met at the trading post. The cattle community of Savage was the midpoint of an old trail winding between the Indian and Kissimmee Rivers. By 1887, enough settlers had moved into the south end of Orange County and the western edge of Brevard County to persuade the legislature to chop off a new county for them. This way, they would not have to travel as far to the county seat, then in Orlando. Kissimmee became the new county seat for Osceola, Florida's 40th county. The pioneer era was ending and St. Cloud would soon rise from what had been flood land.

Two

HAMILTON DISSTON'S ERA

Florida's interior was still a wilderness when Hamilton Disston saved the state from bankruptcy and drained thousands of acres for settlement. His father, English immigrant Henry S. Disston, was 14 when his father died three days after the family arrived in America. Using his factory apprentice's knowledge of how to heat-treat steel to hold a blade's sharp edge, Henry Disston made carpenters' tools. Years later, on his first son's 21st birthday, Henry Disston renamed his Philadelphia saw manufacturing company from Keystone Saw, Tool, and File Works to Disston & Son. Born August 23, 1844, Ham Disston worked in his father's shops as an apprentice. At age 17, he was too young to be recruited for the Civil War. Twice during the war's early years, he enlisted, but Henry Disston paid the bounty for another soldier to take his son's place. Eventually, Ham Disston served as a private in the Union Army, rallying 100 other workers to join him in the Disston Volunteers, armed and equipped by Henry Disston. Hamilton Disston became president of the family business when his father died in 1878. He found his opportunity to become the nation's largest landowner on a fishing trip to Florida's Gulf Coast.

Hamilton Disston was 37 when he became a national celebrity by signing a $1 million IOU to turn Florida's all but worthless wilderness into a winter wonderland. Gov. William Bloxham persuaded Disston to buy four million acres at 25¢ an acre. The deal in June 1881 made Disston the largest individual landowner in the United States.

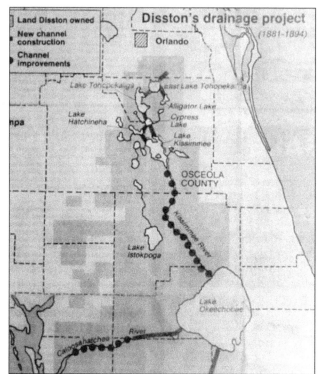

This map shows the route of the Disston dredging. For two bits an acre, Hamilton Disston of Philadelphia bought 6,250 square miles from the Kissimmee-St. Cloud area south to Lake Okeechobee and the Gulf. The Civil War had left Florida broke. Disston's deal with the state allowed him to keep half the land he reclaimed.

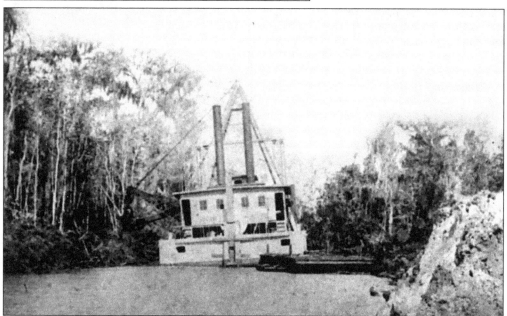

One of Disston's dredges moves south along one of the many canals his crews dug. The dredges drained the swamplands and created land for groves, farms, and cities and forever changed the land. The St. Cloud Canal was completed November 22, 1884. Opening the canal dropped the lake level and thousands of acres of rich soil were revealed. Some 420 acres of this reclaimed land would be planted with sugarcane. Disston bought the sugar cane operation and founded the Florida Sugar Manufacturing Co.

18

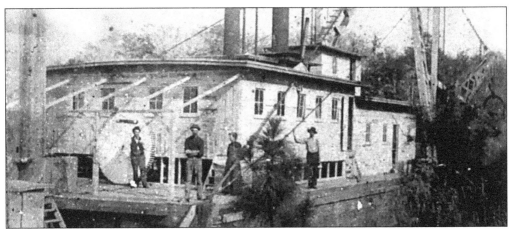

Disston engineer John Garrity and brother and sister Reuben Libby and Abbie Libby stand on one of Disston's dredges at the Brick Lake Canal, c. 1899. The man on the right is unidentified. The dredge was the first home of the Libby siblings when they moved to Florida in the 1880s from Exeter, Maine. Reuben Libby became an expert citrus grove planter, including those at Carolina Station along the highway (now Neptune Road) that he suggested should follow the route of the Atlantic Coast Line Railroad. Garrity would be put in charge of taking apart the sugar mill machinery when it was sold and shipped to Mexico after the plantation closed.

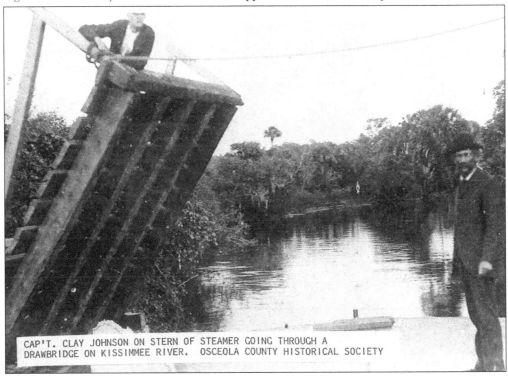

CAP'T. CLAY JOHNSON ON STERN OF STEAMER GOING THROUGH A DRAWBRIDGE ON KISSIMMEE RIVER. OSCEOLA COUNTY HISTORICAL SOCIETY

Steamboat captain Clay Johnson, right, stands on the stern of a steamer going through a drawbridge on the Kissimmee River. Johnson came from Louisiana when Disston offered him the job of superintendent of his shipyard on Lake Tohopekaliga. A reporter in 1911 wrote that Johnson "knows every cove of the lakes and every crook and turn of the rivers in the Kissimmee Valley as well as some men know their front yards."

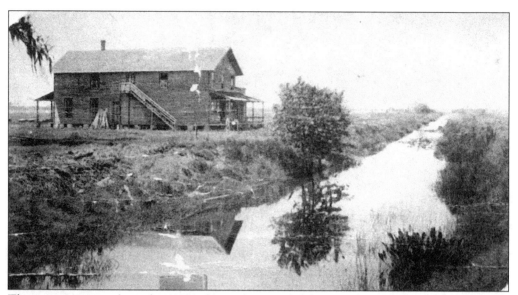

This summer scene from the 1890s shows the St. Cloud Canal flowing through the Disston sugarcane plantation. Capt. Clay Johnson had started his Southport sugar plantation in 1883 at the southern tip of Lake Tohopekaliga. That same year, his brother-in law Rufus E. Rose bought 420 acres on East Lake Toho and built a home. With Pennsylvanian Sam Lupfer Sr. as his partner, he raised sugarcane and operated a small open-kettle mill. Two years later, Disston bought a half-interest in Rose's plantation, built a large sugar mill on East Lake Toho, and enlarged the plantation.

In 1890, S.L. Lupfer Sr., superintendent of the sugar plantation at St. Cloud, established a small private school at what today is Maryland Avenue at Tenth Street. He named it the Sunnyside School.

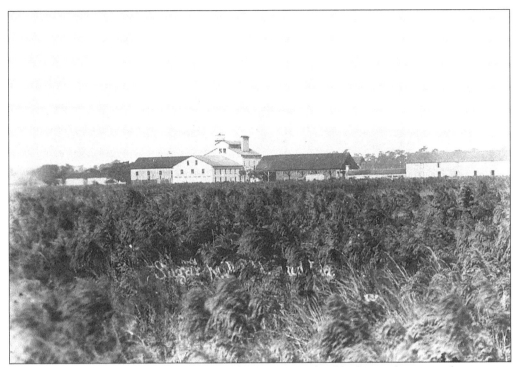

This is the sugarcane mill, shown in the early 1900s. St. Cloud had gained a national reputation for growing sugarcane on reclaimed swampland. The sugar mill on the east bank of the St. Cloud Canal was the most advanced of its time. The mill, built at a cost of $350,000, could produce 200 tons of sugar an hour, making it the largest in the nation.

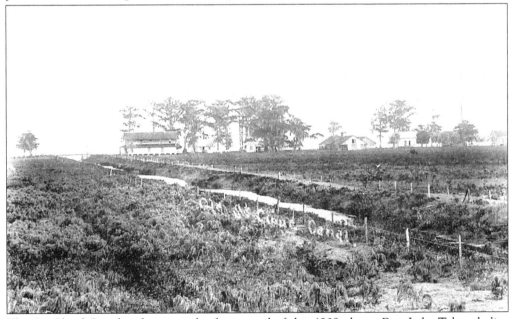

The St. Cloud Canal is shown in the foreground of this 1909 photo. East Lake Tohopekaliga is in the distance. The plantation's commissary, which is today a private residence, and worker houses are near the lakefront.

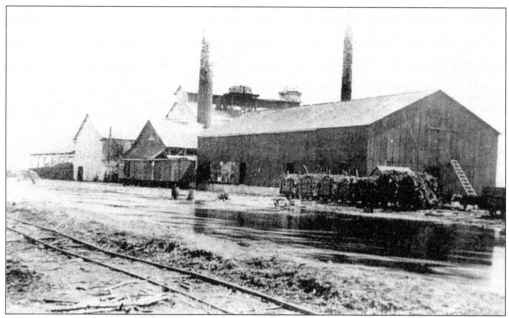

The Disston Sugar Mill was built after dredging completed the canal, which dropped the level of East Lake Tohopekaliga by as much as five feet. Settlers found plenty of work on the dredges and plantations or at the shipyard where steamboats were built to carry laborers and cargo to remote areas being drained.

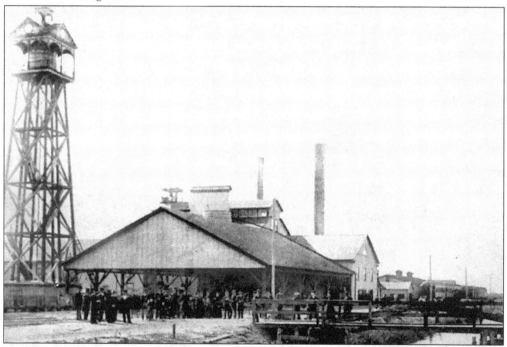

The Disston Sugar Plantation and Mill, built on the east bank of the St. Cloud Canal in 1888, was the most advanced of its time. The Philadelphia entrepreneur's Florida Sugar Manufacturing Co. planted more than 1,000 acres of sugarcane on land he had dredged and drained along East Lake Tohopekaliga.

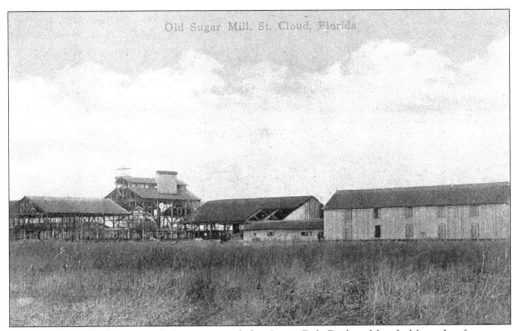

Disston Sugar Mill processed the cane, and the Sugar Belt Railroad hauled barrels of sugar to Kissimmee's steamboat wharfs and railroad depot.

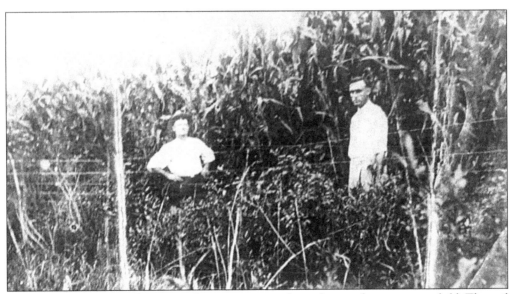

Thomas Brooks, left, and Dana Eiselstein are pictured standing in the sugar cane field. The soil left after the swamp draining was rich enough to grow sugarcane taller than men.

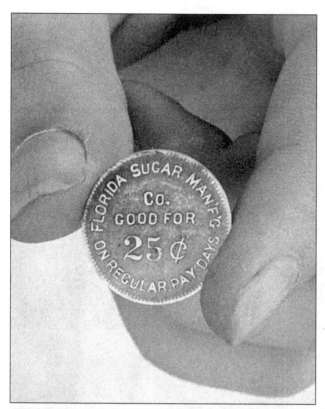

This 25¢ token was issued by Disston's Florida Sugar Manufacturing Co. and given to workers to spend at the company commissary on pay days.

The back of the Disston company token tells workers it could only be spent at the company's St. Cloud store. This token was found on the grounds of the old sugar mill in 1975 and donated to Bob Fisk's collection.

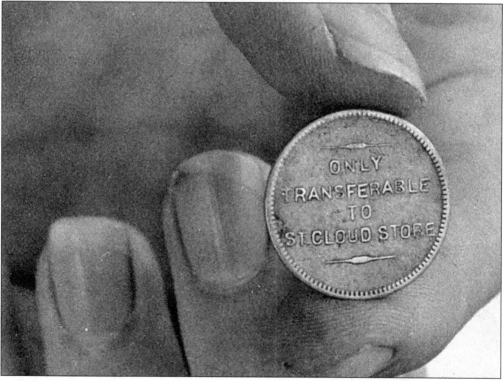

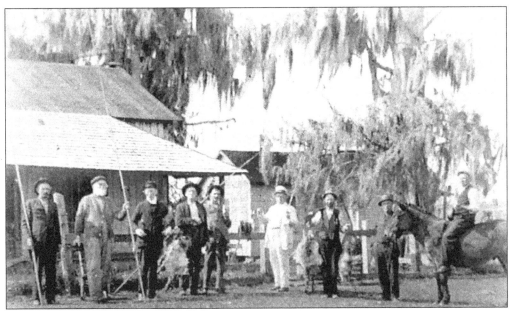

Lemuel Williams, holding the donkey, and other St. Cloud old-timers gather near the area on the canal still referred to as Old St. Cloud. The plantation's commissary and post office were located at Old St. Cloud.

The Disston Co. also planted rice. This family is standing in the rice fields around Fish Lake near Neptune Road. The muck was so rich rice grew too tall. The heads were so large stalks toppled over before the grain was ready for harvest. Experiments, though, found the right rice strain for 5,000 acres. The company provided a tract for the United States Department of Agriculture to fine-tune farming techniques for muck land.

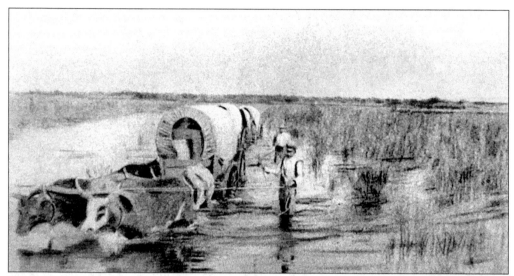

This is the Disston commissary train hauling supplies from Kissimmee through the Cross Prairie lowlands to the plantation and sugar mill. The two-story wood frame commissary and the mill's brick foundation and granite slabs are the last remaining signs of the sugar plantation.

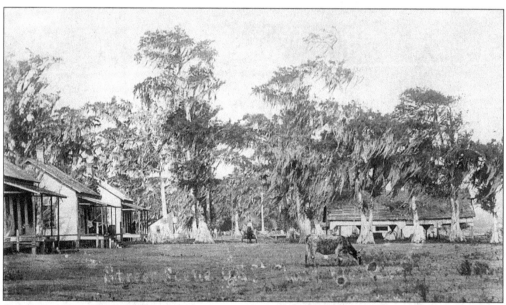

Cattle grazed on the lowlands near the Disston Sugar Mill. The pasture is in front of the cypress trees and houses where Disston workers lived.

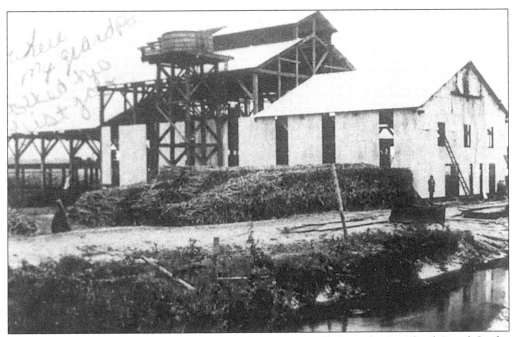

Sugarcane ready for grinding is piled outside the Disston mill along the St. Cloud Canal. In the 1890s, Congress had agreed to pay sugar producers in Florida a bounty of 2¢ a pound for their crop in an effort to slow sugar imports. Disston snapped up the opportunity, lining up investors to provide $1 million to expand his sugar mill and plantation operations to include a second sugar refinery on Lake Okeechobee to process the cane from a total of 20,000 acres.

Sugarcane fields grow near the Disston mill on the St. Cloud Canal. As the fertile land rose from the waters, immigrants hired by Disston's Florida Sugar Manufacturing Co. planted 600 acres of sugarcane that a reporter in 1886 described as "green, waving cane, in one body, spread out like a sea."

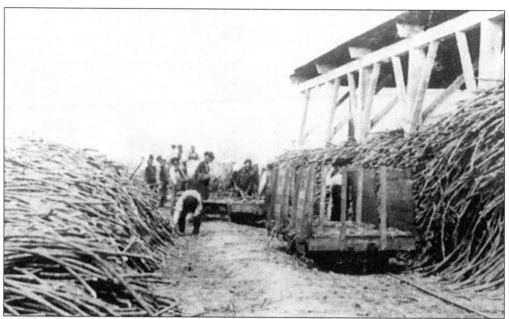

Sugarcane is piled at the Disston mill. Rail cars were used to move the cane into the mill for processing. The mill could process the cane from 1,500 acres. The Sugar Belt Railroad hauled barrels of sugar to Kissimmee.

Much of the land near the sugar mill rose from this muck that just two years before Disston's massive drainage project in the mid-1880s was cypress swamp and saw grass along East Tohopekaliga. Disston's sugar production never reached the potential he envisioned. Cane bores damaged his sugar crops, and his other Florida ventures began taking up more and more of his time.

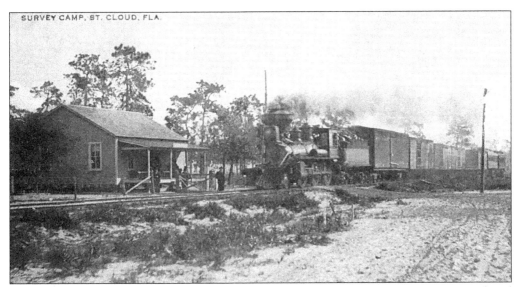

The Sugar Belt pulls into the St. Cloud station in this photo. The sugar factory in 1892 produced more than one million pounds of sugar from about 1,000 acres. But the end was near. The sliding national economy after the Panic of 1893, caused by unsound bank debt and speculation that resulted in a stock market crash, came at a time of over development and land speculation in Florida. They were dark days for those who had invested in Florida agriculture and real estate. Congress canceled the sugar bounty in 1884. Henry Plant's railroad empire swallowed up the Sugar Belt Railroad.

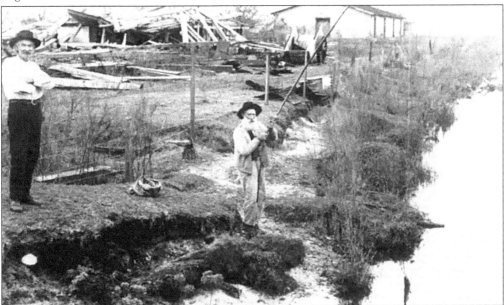

This fisherman stands on the banks of the St. Cloud Canal after the Panic of 1893. In the background is the dismantled Disston Sugar Mill. Just when Disston was nearing the end of his drainage contract with the state and at a time when he had borrowed about all he could by bankrolling his vast land holdings, the nation sank under its worst depression to date. Machinery at his sugar and rice plantations rusted after Disston's holdings came under the control of his Philadelphia brothers, who did not share his enthusiasm for Florida.

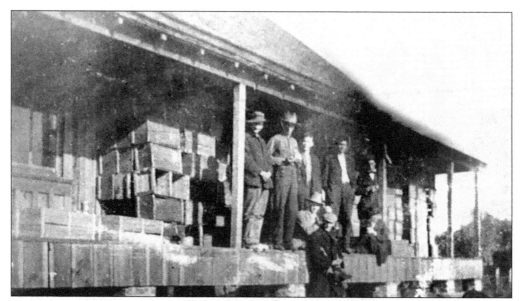

Throughout the Disston era, citrus packinghouses on Lake Tohopekaliga kept the railroad station at Peg Horn busy. The Peg Horn Station also had spur linked to the Disston Sugar Mill. However, the winter of 1894–1895 brought back-to-back hard freezes that killed Central Florida's citrus groves. News of the survival of green saplings in South Florida would persuade Plant's chief railroad rival, oil millionaire Henry Flagler, to push his east coast railroad to the tiny pioneer settlement of Miami.

These pilings along Lake Gentry show some of the last remains of the Disston era. Just below the surface along the shoreline is the abandoned shell of one of Disston dredges. Disston's dream of sweet success had turned sour. Ruined, he committed suicide on April 30, 1896.

Three

THE STEAMBOAT DAYS

Hamilton Disston gave up trying to keep up with his debts. Still, he had accomplished his goal. He created a river highway to the gulf. By the summer of 1884, dredges had drained two million acres of swampland, and steamboats had opened commerce from St. Cloud and Kissimmee to Fort Myers. Boom times had come. When the St. Cloud Canal was finished between Lake Toho and East Lake Toho, steamboat captain Rufus Rose wanted to make the first trip. Rose had dammed the canal with logs, but other captains tried to free a passageway. They failed, and Rose took the honor the next day. Rose later regained political influence. On May 12, 1887, Osceola County was formed by the state legislature from portions of Orange and Brevard Counties. Rose was elected as first chairman of the County Commission. The steamboats plied the waterway from the 1880s until the 1920s, but the railroads lured potential passengers away. One railroad company issued a brochure describing the old steamer lines: "Back then, one of the so-called attractions was a trip to the Upper St. Johns River, with illimitable swamp on either side, and reptiles, falling limbs and gallinippers to render the experience one never to be forgotten. . . . Now, the Upper St. Johns, with its played out, cramped up steamers and six by six staterooms are little heard of and seldom patronized except by the very venturesome or very verdant." Still, Florida's first tourists saw Florida's interior by steamers.

Rufus Edward Rose was a Louisiana chemist and Mississippi riverboat captain when Hamilton Disston selected him in 1881 to manage his land company and, later, to supervise a nearby sugar plantation. Disston had learned of Rose from his work with the Louisiana Reclamation Co., which dredged up peat and muck from the Mississippi Delta.

31

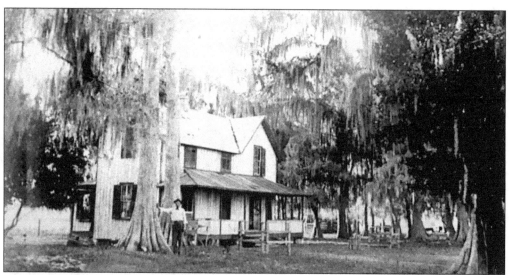

The Rose Cottage at Old St. Cloud is a lasting memory of Rufus E. Rose, a former Mississippi riverboat captain hired by Hamilton Disston to manage his land company in Kissimmee. Rose platted the city streets and suggested the city's name after the river Disston's dredges were widening and deepening. Rose built his home on East Lake Tohopekaliga. He was chairman of Osceola's first county commission when it convened on August 6, 1887, three months after state legislators sliced off portions of Orange and Brevard Counties to give the 815 pioneer settlers, who were spread out over the new 1,325-square-mile county, their own government.

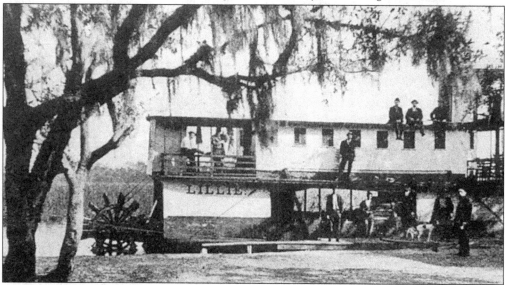

Rufus Rose's stern wheel steamer *Lillie* docks to allow charter passengers to board. Rose and his brother-in-law, riverboat captain Clay Johnson, both Disston managers, often carried tours through the lakes and river to promote land sales. Rose's sugarcane partnership with Disston ended in 1890. Disston's aggressive expansion plans for the sugar operations clashed with Rose's more conservative approach. Rose turned out to be right. Disston lost everything when he was overwhelmed by speculation debts after Florida's land boom busted and the United States economy crashed a few years later. Rose landed an appointment as the state's agricultural chemist, a post he kept until his death.

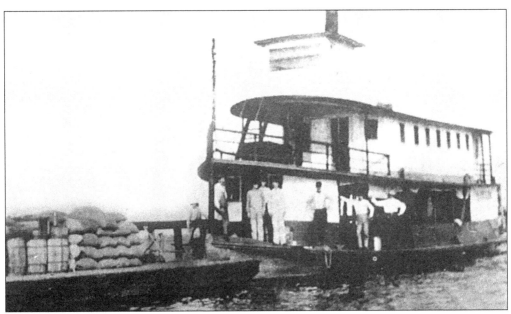

The *Lillie*, loaded and pushing a loaded barge down the Kissimmee River, took its name from the wife of Capt. Rufus Rose.

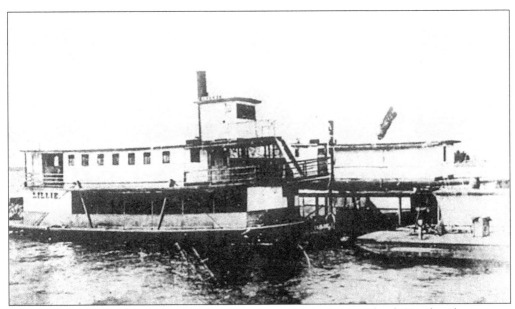

Lillie rests at the dock on Lake Tohopekaliga. By dredging the St. Cloud Canal and a steamer channel from Lake Tohopekaliga to Lake Okeechobee and east along the Caloosahatchee River to the Gulf, Disston and others brought steamer travel and industry. Ranchers dug smaller channels to link up with Disston's canal system and drain marshes for pastures.

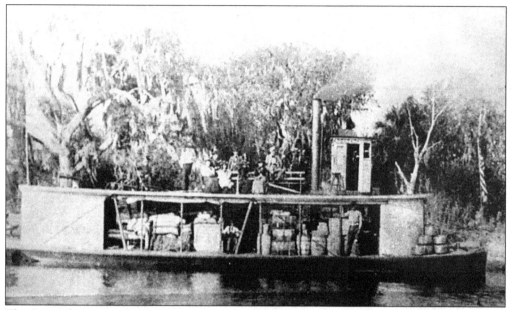

The *Rose-Ada* steams along. Built as the *Cincinnati*, the river cargo boat was renamed twice by Clay Johnson. This photo shows her before she got a new hull and a third name, *Roseada*, for his daughters, Albina Rose and Ada Roberta. Johnson often ferried prospective land buyers down river to Fort Myers. His last ship was the *Osceola*, built in 1910. Fully loaded with 1,000 boxes of oranges, the nearly 75-foot steamer could still make 12 mph upstream.

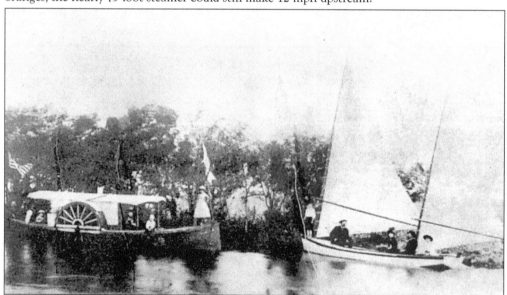

The *Mamie Lowne*, shown steaming ahead of a sailboat, was Capt. Clay Johnson's first steamboat. It burned kerosene to heat its steam engine. The small side-wheeler was used to tow barges across Lake Tohopekaliga, through the St. Cloud canal, and on to East Lake Toho, as well as to deliver machinery to Disston's Sugar Plantation and Mill. Johnson ran a successful steamer line on the lakes and along the river to Lake Okeechobee until the 1920s. His family had followed him to Florida in 1883. With lumber cut from the largest island in Lake Tohopekaliga, he built a big house with a wrap-around porch where he entertained with tunes on the fiddle, fife, or flute.

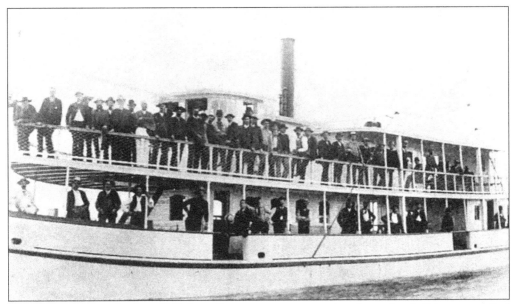

The *Floridelphia* was built in 1883 for a Cincinnati company who planned to build a town called Floridelphia on Lake Kissimmee. That project failed but the steamer *Floridelphia*, at 105 feet from stem to stern, was the biggest of the Kissimmee-built riverboats. It had a 40-horsepower motor. The *Floridelphia* ended its days in South America and, eventually, Los Angeles.

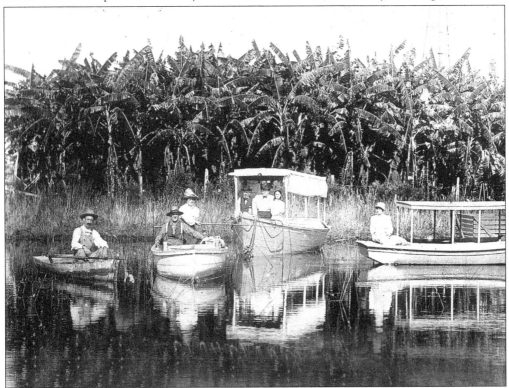

Four small boats are shown on the St. Cloud Canal. Behind them are banana trees growing on the canal banks.

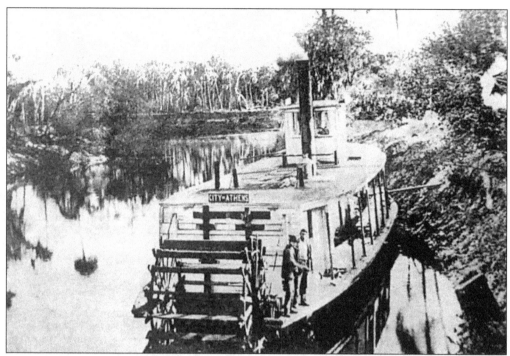

The steamboat *City of Athens* handled freight and passengers from the north end of the Disston-dredged river to the south. Osceola and Brevard Counties were home to many Seminoles during the steamboat era. Sometimes Seminoles boarded the boats to sell souvenirs to passengers.

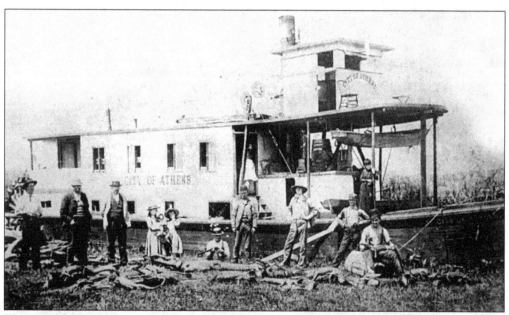

The *City of Athens* is pictured on the Kissimmee River. The riverboat captains befriended the Seminoles they met and traded tobacco, whiskey, conductor hats, bandanas, handkerchiefs, and ammunition for deer and alligator hides that they could sell to tourists.

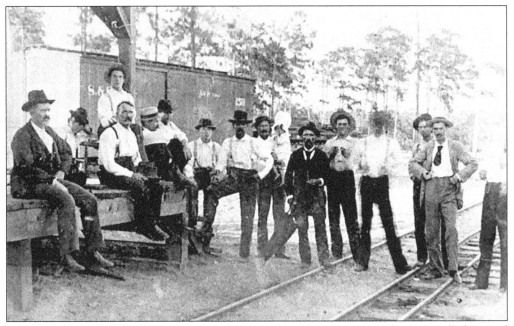

Men gather at Peg Horn Station during the time the narrow gauge tracks were pulled up and replaced with standard gauge tracks. The best of the riverboat captains couldn't fight the railroads, and later, couldn't fight paved roads for trucks.

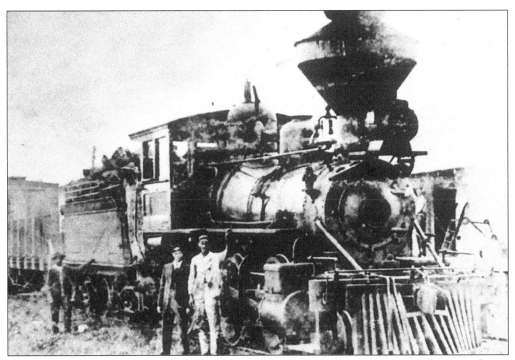

The Sugar Belt's Engine #645 with Ira Bass as engineer and Mr. Konova as conductor is shown in the early 1900s as new railroad lines took away steamboat commerce.

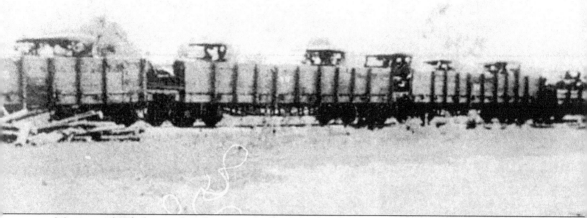

Motorcars loaded on railroad cars cross the St. Johns River at Deer Park in 1923–1924. By the 1920s, the steamers were on their way out. In a historic twist, steamboat captain Clay Johnson had a role in his own fate: his steamers hauled most of the materials to build a toll road that linked Okeechobee and West Palm Beach. Johnson retired in Kissimmee in 1926 after the last of his steamers, the *Osceola*, sank. As if to close their era together, Johnson and Rufus Rose both died in 1931.

Four

THE GRAND ARMY
OF THE REPUBLIC

In the mid-to-late-1800s, cattlemen rounded up scrub cattle, descendants of the herds brought to Florida by Spanish explorers centuries earlier, and drove them across the Kissimmee River Valley to Tampa, Bradenton, or Punta Rassa. As Spanish schooners and steamers sailed for Cuba, the cattlemen returned home with saddlebags of gold and silver coins. By the late 1800s, a war was looming over Spain's control of Cuba and the desire of the United States to flex its muscle as a power on its side of the world. Floridians lobbied to avoid a war, as many feared that once American soldiers defeated the Spanish, Cuba would become U.S. soil and a threat to the state's tourism and agricultural economy. When the Army selected Tampa as its staging area for troops and supplies, hundreds of workers from interior Florida raced to build new buildings and military depots. Many of the troops arrived by rail, seeing Florida for the first time on the ride to Tampa Bay. When Congress declared war in April 1898, they included a rider that Cuba would not become an American territory. Overnight, Floridians threw their support behind President William McKinley's war effort. Florida would enjoy boom times during the brief but peaceful years following the war. Veterans of the Spanish-American War would become some of the first to buy lots at a military retirement community that would become St. Cloud.

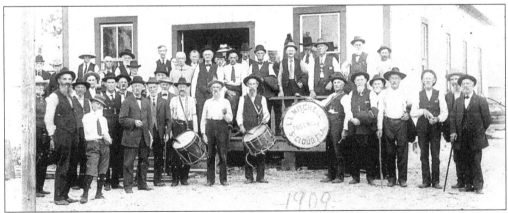

Members of the Grand Army of the Republic's (G.A.R.) L.L. Mitchell Post No. 34 assemble in front of the first G.A.R. Hall in 1909. These are the first veterans to buy land and settle in St. Cloud. Mitchell, shown standing between the two drummers, was a Civil War Union private. He would be the first veteran to die in St. Cloud. He was reburied near a memorial to veterans at the Mount Peace Cemetery, after having been originally buried in Kissimmee's Rose Hill Cemetery.

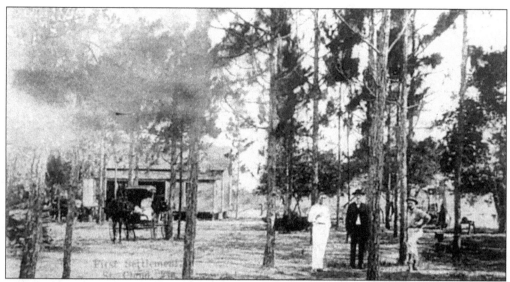

Major Jenkins, Frank Chase, and W.G. King are shown in 1909 at Ninth Street and Ohio Avenue. The Seminole Land and Investment headquarters is in the background. The Grand Army of the Republic Association sent agents to scout out potential sites for an "old soldiers' colony." After looking at sites from Alachua County (Gainesville) south to Lee County (Fort Myers), the veterans bought 35,000 acres of the abandoned St. Cloud plantation in 1909.

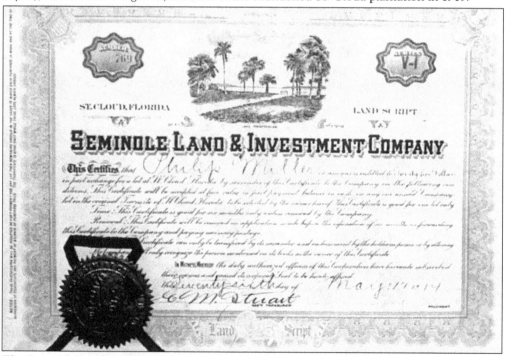

The Seminole Land and Investment Co.'s land script at the St. Cloud "Soldiers' Colony" showed a palm-lined scene of East Lake Tohopekaliga. A lottery in Atlantic City was held for the first lots—each 25 feet by 150 feet—plus five acres outside the town. The first 1,200 lots were sold for $50 by May 7, 1909. This land script was issued to Philip Miller in May 1914 for the purchase of a town lot and farmland.

40

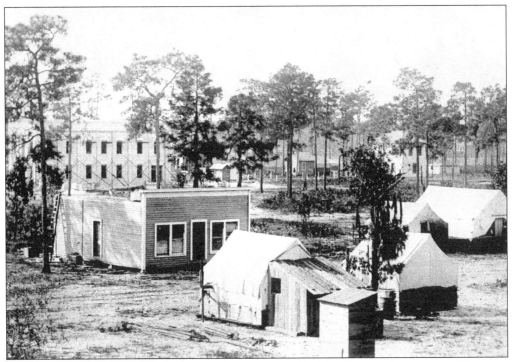

St. Cloud's first veterans lived in tents that were provided by the war department. The tents were set over wooden floors and wooden walls on three sides. Several, including the one shown here in the foreground, had extra rooms built on.

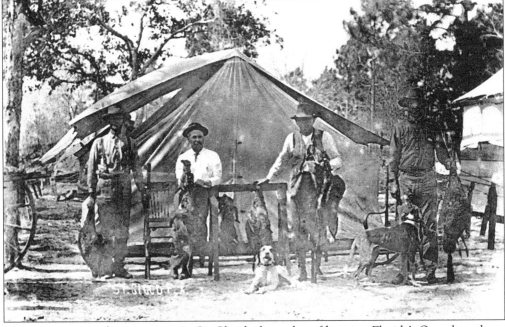

Hunters return to the tent camp in St. Cloud after a day of hunting Florida's Osceola turkeys, some of the most difficult game birds to shoot. Veterans lived in tent camps for the first few months after their arrival while more suitable housing was built.

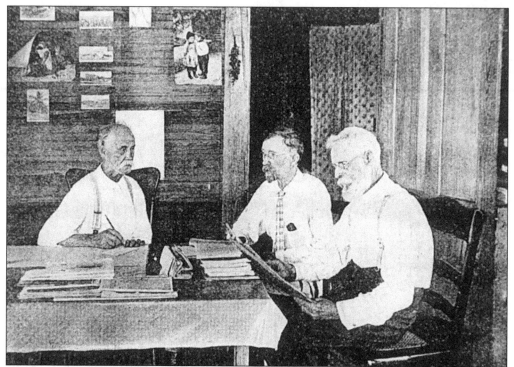

This is the office of the St. Cloud Veterans Association. Secretary A.H. Kinney is seated on the left, taking notes. President Robert Anderson is reading the *St. Cloud Tribune* on the left. The man in the middle is unidentified. He could be one of the two other association officers, W.H. Wood, treasurer, or Philip Mohr, vice president.

The first St. Cloud Hotel, built on New York Avenue, is on the far left in this scene that also shows the tent camp and the first Makinson hardware store in St. Cloud. The family-owned store started in Kissimmee and continues today as Florida's oldest retail hardware store.

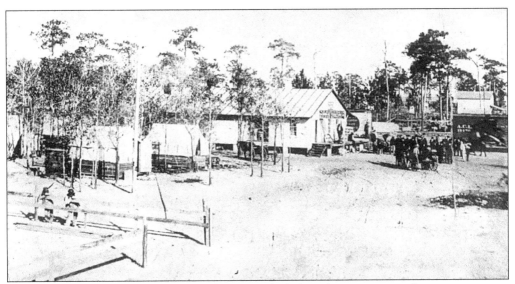

Seminoles, shown leaning on the wood fence at the left in this scene, were frequent visitors to early St. Cloud. Many served as hunting guides. Also in this photo is an Atlantic Coast Line Railroad train car most likely delivering building supplies to the W.B. Makinson Co. hardware store, shown in the center. A few of the Army-issued tents for the campground can be seen in the midst of the trees on the left.

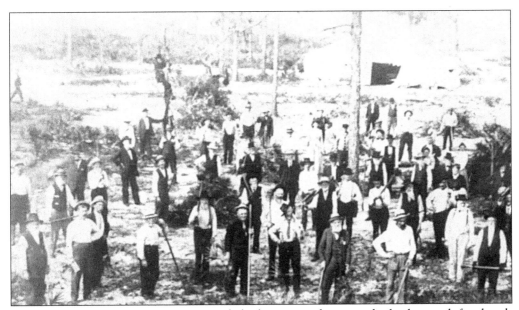

The Southern Baptist Convention provided a large tent, shown in the background, for church services in St. Cloud in 1909. Shown are veterans who assembled with their tools to clear grounds for a church.

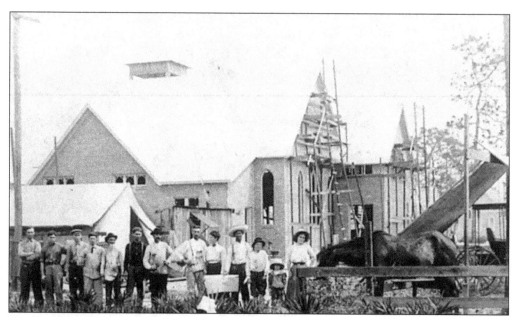

Tents were still in use when volunteers pitched in to build a Methodist Church on the southwest corner of Tenth Street and Ohio Avenue.

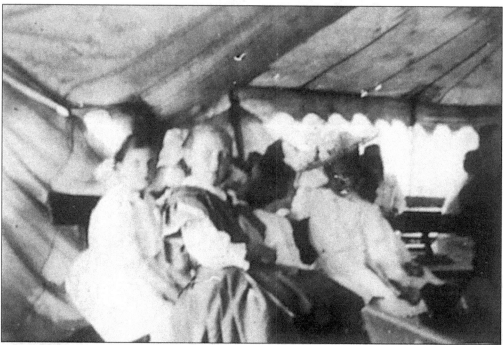

This view shows the inside of the church tent on Massachusetts Avenue during one of the early services. The site was later used for the library. Lillian Ide White, one of the women in this photo, joined the church in the tent and was the last surviving founding member when she died in the 1980s.

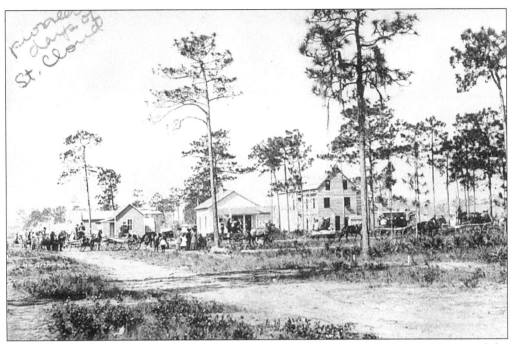

Horse-drawn wagons arrive for a community gathering along New York Avenue, one of the first state-named streets in what now is the downtown historic district. These early wood-frame buildings were later replaced with brick buildings.

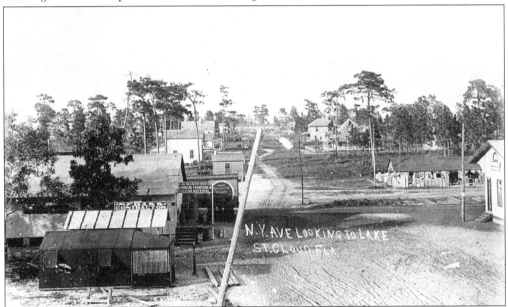

As new buildings were completed, the tent city came down. This 1910 scene is looking north along New York Avenue. N.F. Bass, a building contractor, ran his business out of the first structure on the left. Next door was the Makinson store, which sold hardware, furniture, and building materials. East Lake Tohopekaliga is in the background. Railroad tracks run east and west, and the depot is on the right side. An Atlantic Coast Line railcar is stopped behind the hardware store.

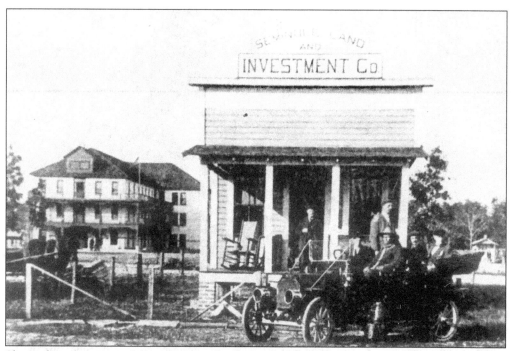

Shown here are some of the officers and sales staff of the Seminole Land and Investment Co., the real estate sales promotion company founded by the G.A.R. to market St. Cloud land to veterans. On the left in the background is the three-story St. Cloud Hotel, where many of the first veterans stayed while their homes were under construction in the early 1900s.

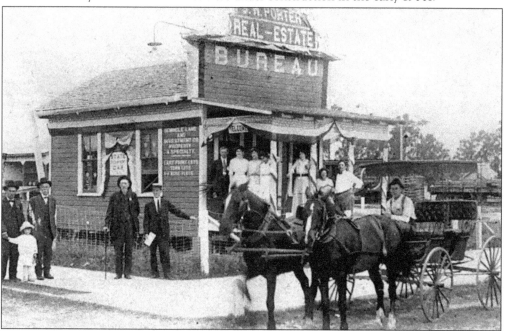

A horse and buggy driver pauses for this 1910 photograph in front of S.W. Porter's real estate office. Porter specialized in selling land offered by the Seminole Land and Investment Co. Buyers could find lakefront lots, town lots, and land cleared for farming.

46

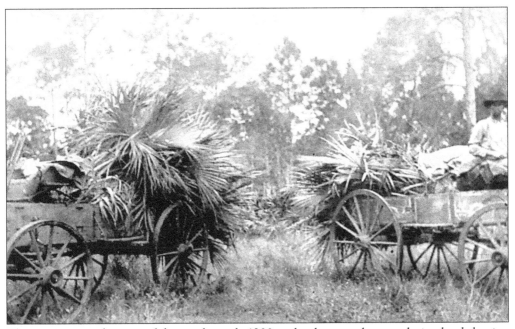

These wagons are being used during the early 1900s to haul away palmettos during land clearing for the new town of St. Cloud.

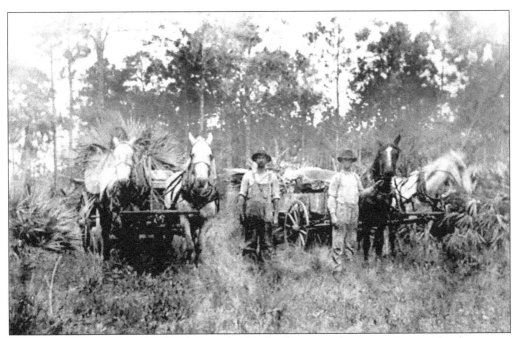

Teams of horses were used to haul wagonloads of palmetto and other undergrowth when crews cleared land for St. Cloud's new houses.

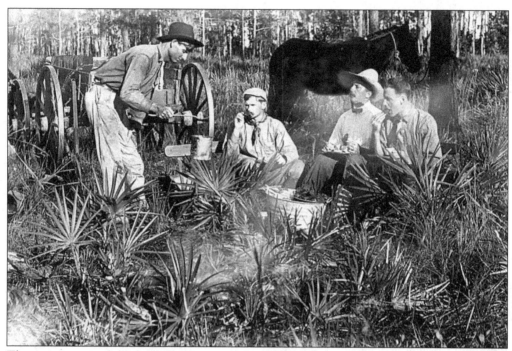

These men, part of the land-clearing crews for the early home sites of St. Cloud, pause for a noon meal of hot coffee, beans, cornbread, and sweet potatoes cooked over an open fire in the pine and palmetto scrubland.

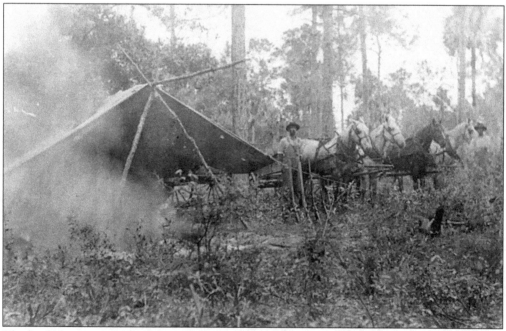

The land-clearing crews built lean-to tents supported by pine timbers as their temporary homes. They built wood fires to drive away mosquitoes while working deep in the woodlands.

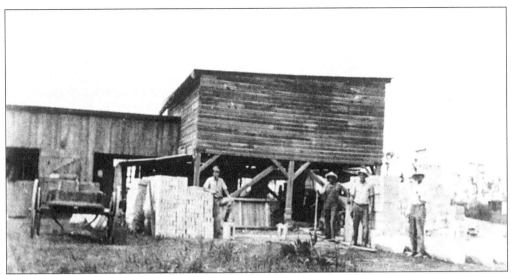

This is the early cement block plant in St. Cloud. The man with his right arm resting on the stack of blocks is believed to be Mr. Mallet.

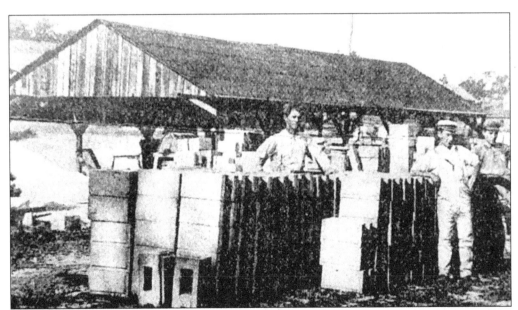

Workers at the Collin's New York Avenue Concrete Works plant show the blocks that will be used to build St. Cloud.

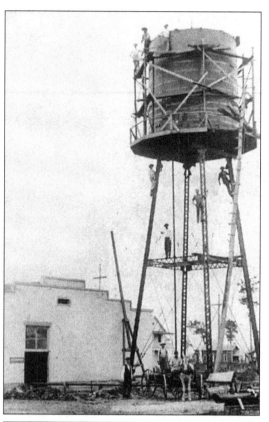

One of the St. Cloud veterans' first projects was to build a wooden water tower. It was erected at the Seminole Land and Investment Co.'s ice plant at Tenth Street and Minnesota Avenue in 1910. Water came from an artesian well 912 feet deep. The Fairbanks-Morse Co. manufactured the machinery for the water works and electric lights. The plant could serve 10,000 people, and the ice plant could provide 10 tons daily.

The veterans who built St. Cloud provided electric power and ice from this plant. This photo was taken in 1910.

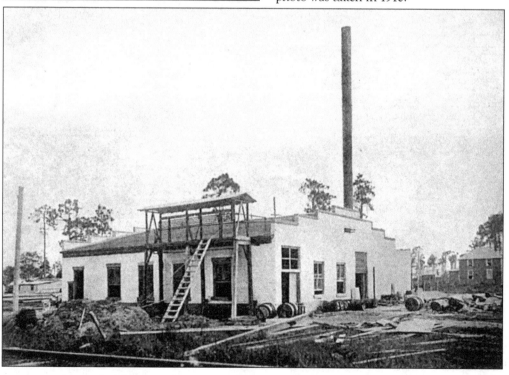

This cutaway shows how lumber was cut and fitted together to form the wooden pipe used for the St. Cloud water mains. The last of the old pipe was still in good condition and still in use when removed and replaced in the 1950s. The St. Cloud Public Utilities Co., after raising $100 in stock sales, also installed telephones.

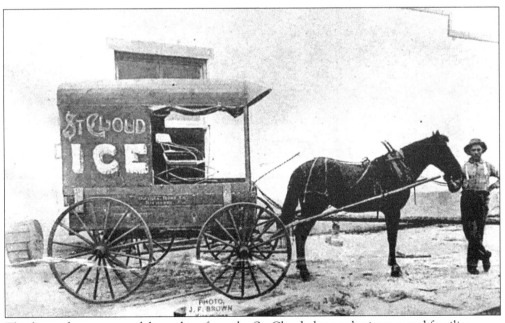

This horse-drawn wagon delivered ice from the St. Cloud plant to businesses and families.

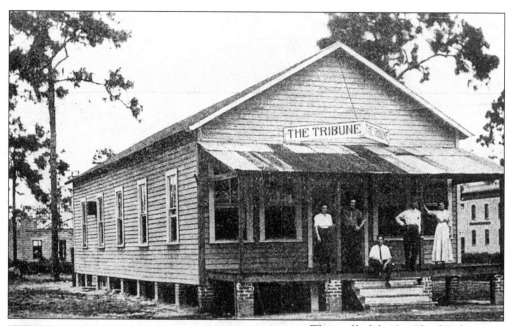

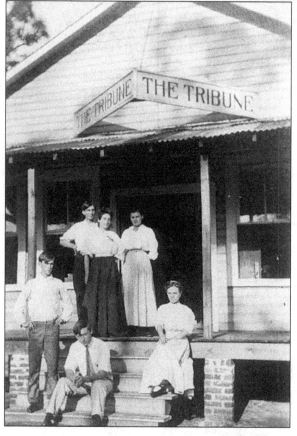

The staff of the *St. Cloud Tribune* pose on the newspaper office porch. Reporters worked out of this building on Massachusetts Avenue, and they told the first stories that attracted new citizens. The October 14, 1909 edition reported that the hotel was full and "many are sleeping on cots in the hotel parlor and other available places. Many people have purchased tents and are living in them in various parts of the town until they can have homes erected. Several have decided they will live in the tents through the winter, as they find tent life enjoyable, especially as the rainy season is now over, and the weather is delightful."

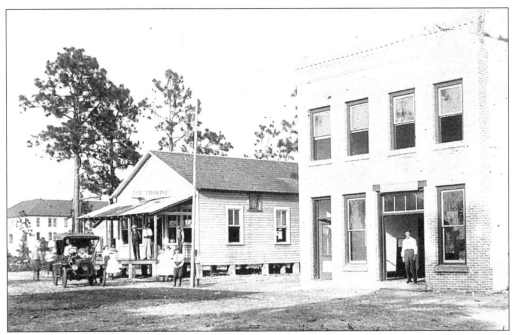

T.C. Roberts stands in the doorway of the St. Cloud Post Office on Massachusetts Avenue near Twelfth Street. The *St. Cloud Tribune* office is next door. For a time, the top floor of the post office included the classroom of an early school.

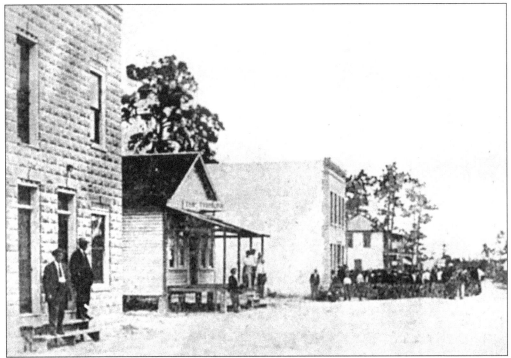

The *Tribune* newspaper office is shown in the center along Massachusetts Avenue. In the background, voters line up on November 5, 1912. This photograph appeared in the *National Tribune* on December 19, 1912.

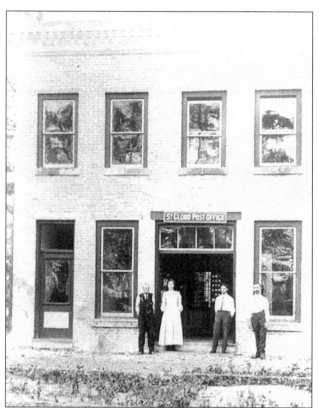

This is the first cement block post office in St. Cloud. The woman in the doorway is Ella McAllistar. On far right is Thompson C. Roberts. The other two men are not identified.

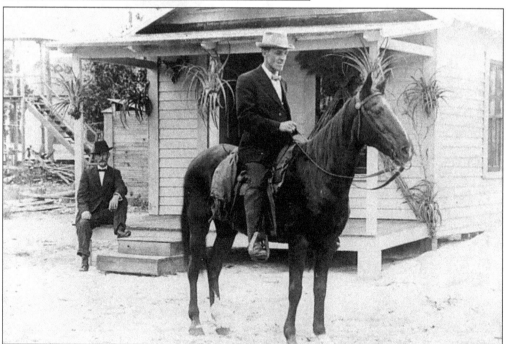

T.C. Roberts is the man on the horse in front of his real estate office between New York Avenue and Pennsylvania Avenue and Eleventh and Twelfth Streets.

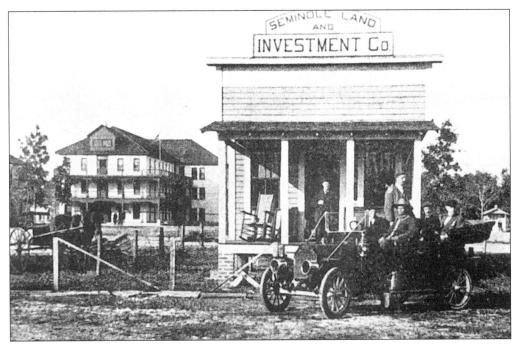

This is the Seminole Land and Investment Co. real estate office on Pennsylvania Avenue. The St. Cloud Hotel can be seen in the background. At this time, St. Cloud residents still used horses and buggies as well as early automobiles.

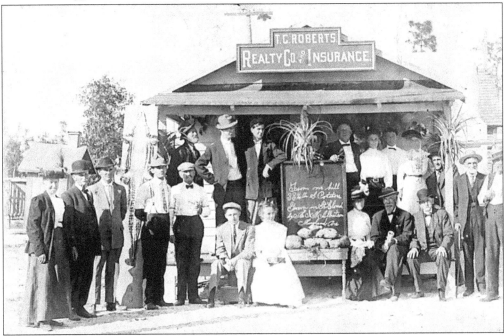

T.C. Roberts ran his real estate and insurance businesses out of this building. Proud gentlemen farmers and their wives are shown around a table loaded down with huge sweet potatoes. The chalk writing on the blackboard reads, "From one hill 33 1/4 lbs. S. Potatoes Grown in St. Cloud by I.N. Albertson Maryland Ave."

Grand Army of the Republic veterans and their wives pose on the porch of early houses completed after the G.A.R. began selling city lots and farmland to Civil War and Spanish-American War–era veterans.

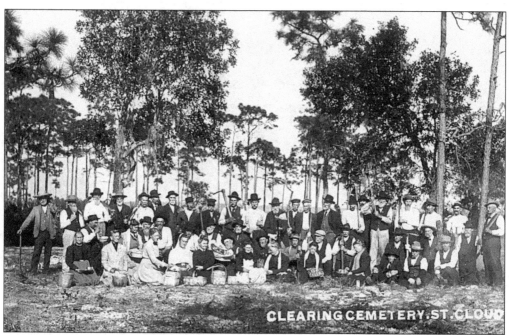

St. Cloud veterans stop work while clearing land for a cemetery. Wives of the veterans are shown on the left with picnic baskets. Lobbying for a new cemetery began during the first year of the new town. Residents had been using the cemetery in Narcoossee. The Mount Peace Cemetery would become the centerpiece for the community's memorials for war veterans.

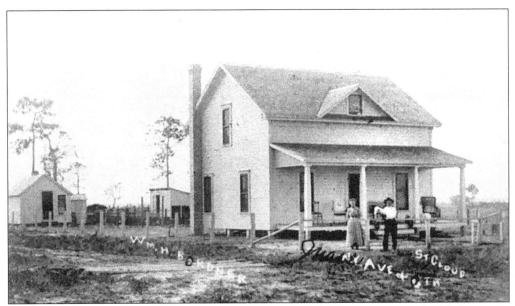

This is Mr. and Mrs. William H. Dordner's home at Massachusetts Avenue and Fifth Street.

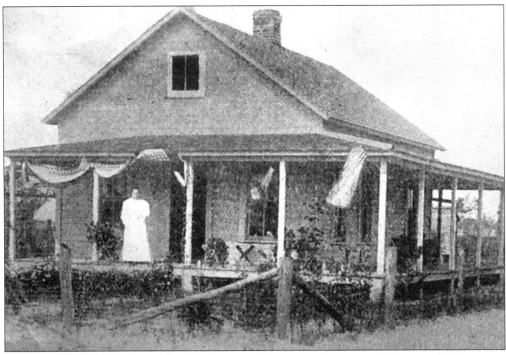

Mrs. Anna Blaich, on the porch of her home at Minnesota Avenue and Fourteenth Street, was one of the many early St. Cloud homeowners who proudly displayed the Stars and Stripes and American flag banners.

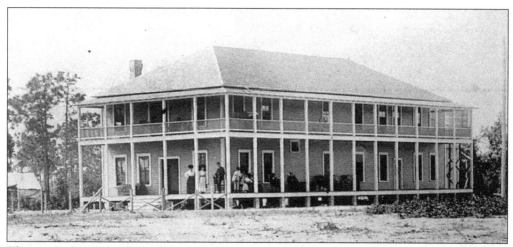

The original St. Cloud Hotel, built in 1909 from material scavenged from the Disston Sugar Mill, would be destroyed in the new town's first disaster.

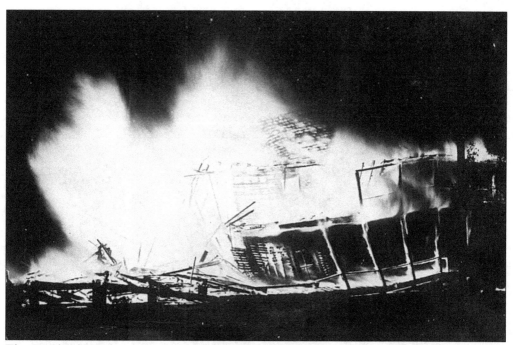

The St. Cloud Hotel is shown as it was burning in December 1909. This photo, taken at 3 a.m., was made into a postcard. This one is postmarked January 3, 1910, and was mailed to a friend in Auburn, Maine. Its sender described the fire and then closed with the following: "We are having fine weather. Am going around in my shirt-sleeves today, Frank."

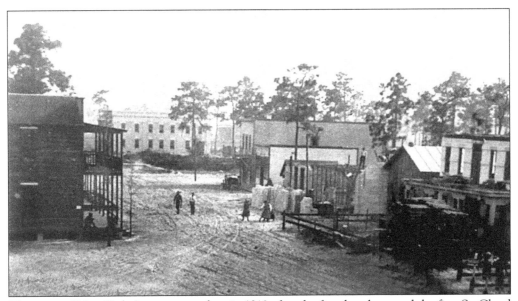

This view of New York Avenue was taken in 1910 after the fire that destroyed the first St. Cloud Hotel. The new hotel is under construction on the right.

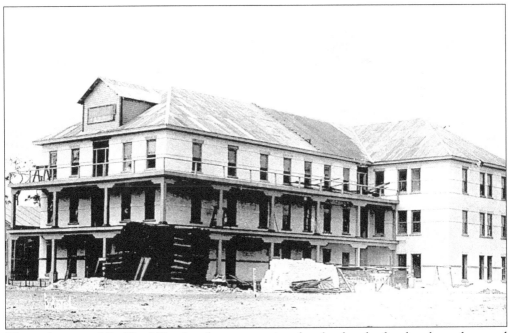

This is the second St. Cloud Hotel under construction shortly after the first hotel was destroyed by fire. The three-story masonry structure had 72 rooms and wrap-around verandas on each floor. It became was the social gathering center of its time.

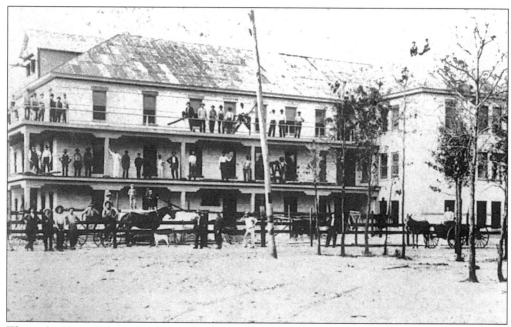

This side view of the second St. Cloud Hotel in 1911 shows many of the veterans who lived there while their houses were under construction.

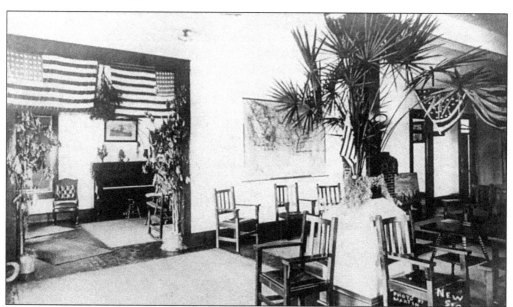

This is the lobby of the second St. Cloud Hotel as it appeared when it reopened.

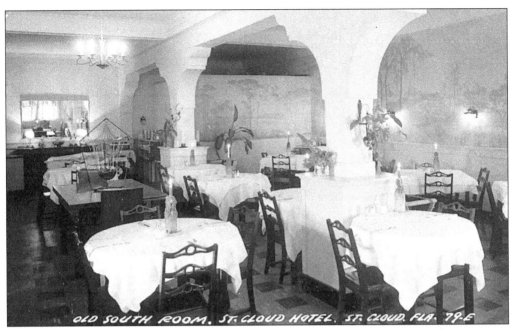

This picture shows the Old South Room dining area of the rebuilt St. Cloud Hotel.

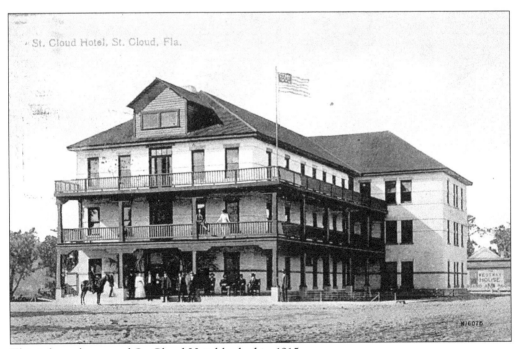

This is how the second St. Cloud Hotel looked in 1915.

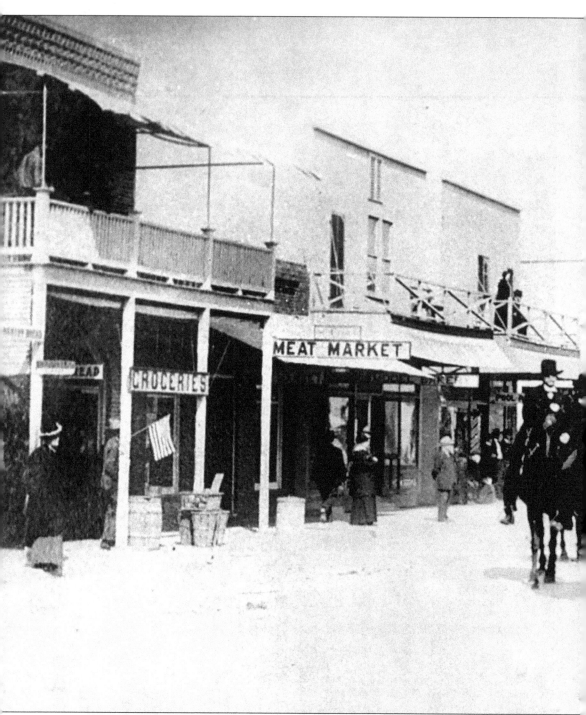

This scene of St. Cloud's Pennsylvania Avenue was taken during the Old Settlers' Day Parade, one of many held during the town's early years. The first veteran, Albert Hantsch of Chicago, arrived on May 21, 1909. A year later, St. Cloud had 2,000 residents. The *St. Cloud Tribune* reported that the residents had a post office, a waterworks, a telephone system, an electric light plant, 43 stores and other businesses, a national bank, six churches, a library, a Board of Trade,

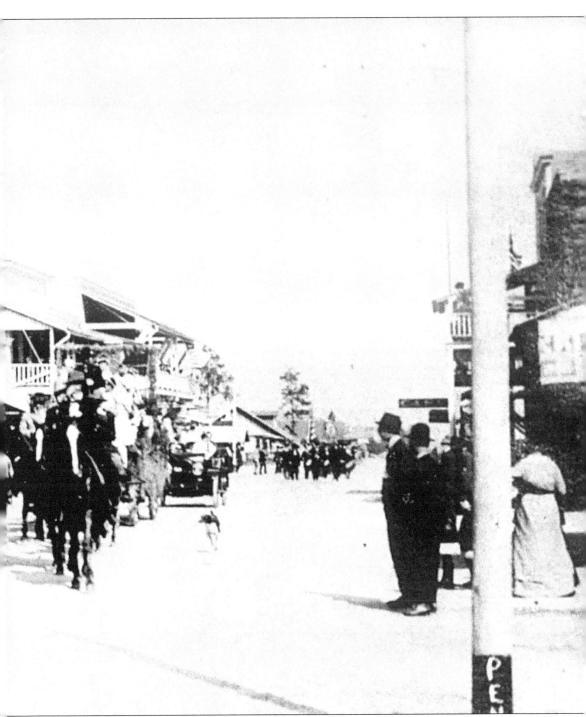

a Veterans Association, a G.A.R. Post, $8,000 in monthly pensions, plus "climate with no extremes, colonists from every state, unusual opportunities, room for more people." "Not a bad start for a community just one year from the palmetto scrub," the newspaper noted. St. Cloud would benefit for Florida land-sales boom of the early 1900s.

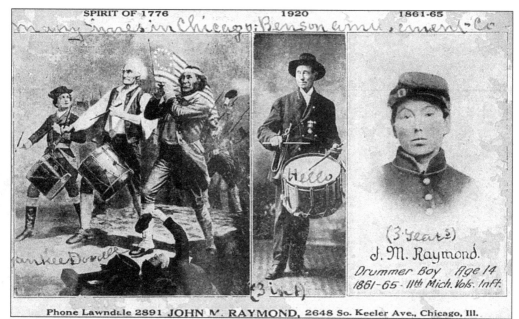

SPIRIT OF 1776 — 1920 — 1861-65

many times in Chicago; Benson amusement Co

yankee Doodle

Hello

(3 in.)

(3 years)
J. M. Raymond.
Drummer Boy Age 14
1861-65 - 11th Mich. Vols. Inft.

Phone Lawndale 2891 JOHN M. RAYMOND, 2648 So. Keeler Ave., Chicago, Ill.

Early St. Cloud resident John M. Raymond, shown here in the middle in 1920 and at a younger age on the right, was among the early veterans to retire to St. Cloud. While living in Chicago, he added this Spirit of 1776 fife and drum image and the photos of himself for a postcard. Raymond was 14 when he signed on as a drummer boy during the Civil War for the 11th Michigan Volunteers, an infantry unit. He served as National Drum Major for the veterans' organization. "May the Stars and Stripes forever wave over the Land of the free and the home of the Brave," he wrote on the back of this postcard.

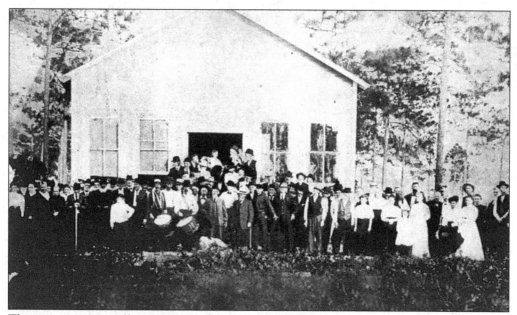

The temporary post office at St. Cloud provided the backdrop for a meeting of the old veterans. G.A.R. members held many of the first meetings in this hall.

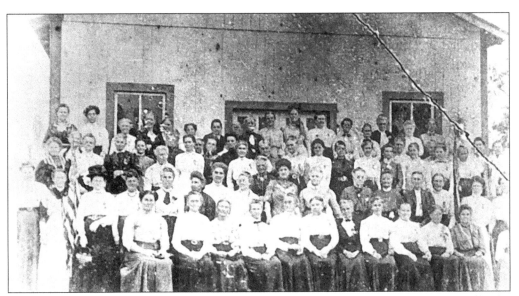

The Women's Relief Corps posed for this 1911 photo in front of the original G.A.R. Hall. The women's group was an auxiliary to the G.A.R, and they met twice a month to plan and organize community improvements.

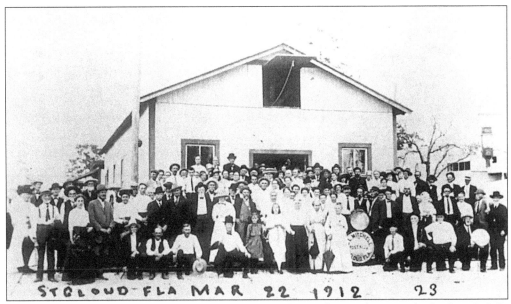

G.A.R. veterans, the Women's Relief Corps, and family members gather outside the first G.A.R. Hall on March 22, 1912.

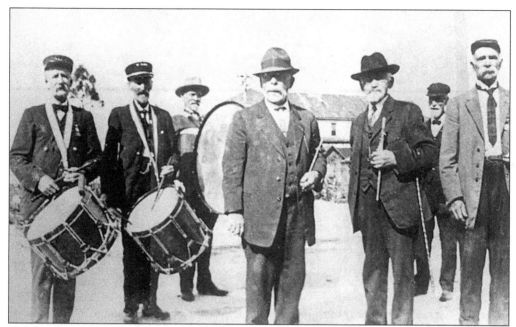

Veterans of the G.A.R. Fife and Drum Corps gather before a parade.

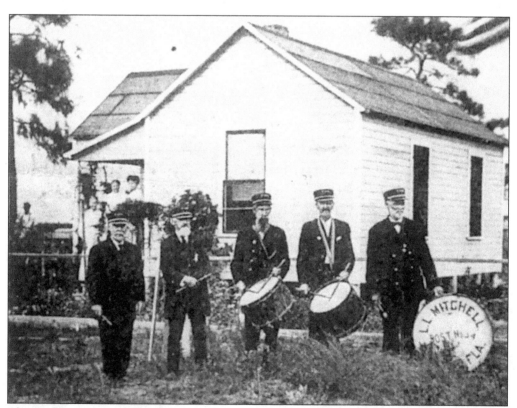

The St. Cloud Fife and Drum Corps of the L.L Mitchell G.A.R. Post 34 included, from left to right, N.W. Fergason, T.F. Van Arsdale, W.A. Stewart, Joseph Burbank, and L.Q. Bowers.

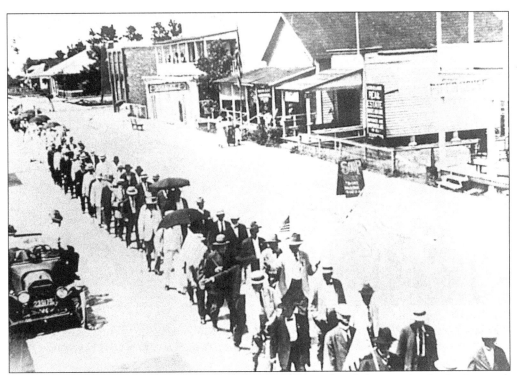

A veterans' parade moves down New York Avenue. The railroad depot is in the background. The bank building at Tenth Street, the New York Stores, the Bon Air Hotel, a real estate office, and the Pifer House are visible.

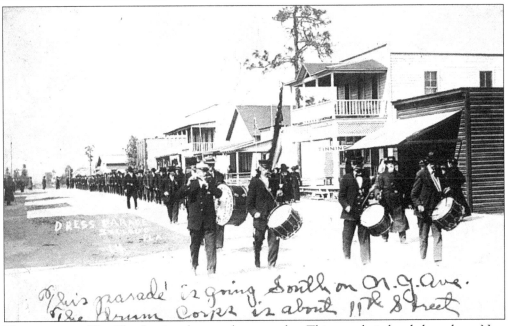

This parade is going South on N.Y. Ave. The Drum Corps is about 11th Street

The veterans of St. Cloud enjoyed many dress parades. This parade is headed south on New York Avenue. The members of the St. Cloud Veteran Fife and Drum Corps leading the parade are at New York Avenue and Eleventh Street. The Pifer House is in view.

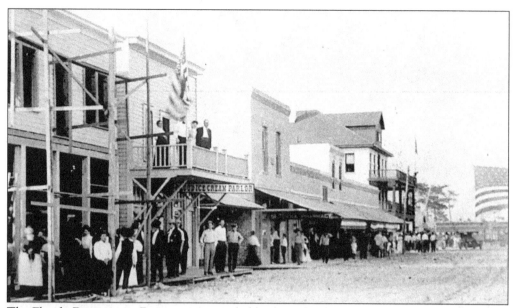

The Florida Department Encampment was held in St. Cloud in 1911. This photo was taken on February 14, 1911, as G.A.R. representatives gathered downtown on the G.A.R. Camp Fire Day. Many of the businesses flew American flags. This is New York Avenue. Note the passenger train in background.

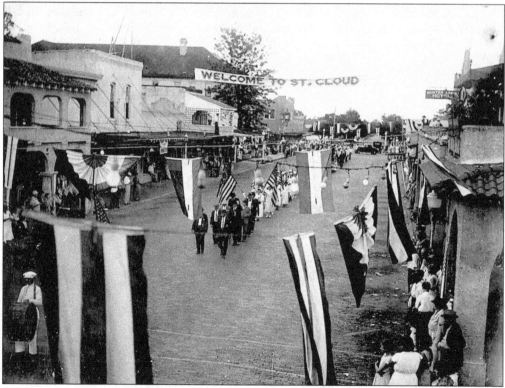

A "Welcome to St. Cloud" banner is draped across the town's New York Avenue for a veterans' parade. The parade is just reaching the Hunter Arms Hotel, built by banker Grover Hunter.

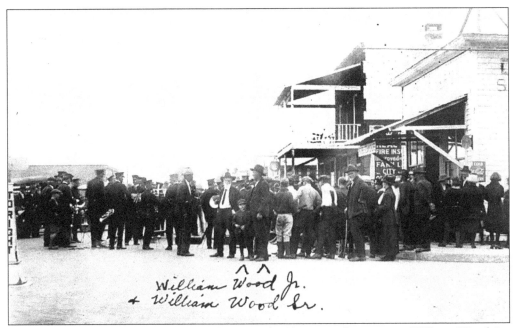

William Wood Jr.
+ William Wood Sr.

Veterans gather on New York Avenue for a parade. Shown in the center is William Wood Sr., looking west, and William Wood Jr., the boy in the cap looking at the camera.

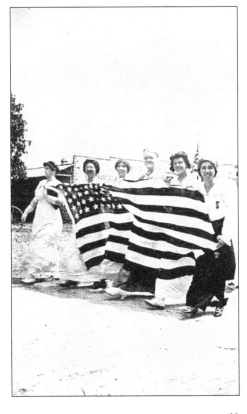

These ladies pass the W.B. Makinson Hardware Store during a patriotic parade. They had plenty of reason to march with pride, as women in St. Cloud won the right to vote in city elections two years before women's suffrage became a nationwide right. In St. Cloud, 500 women became voters after the city charter was changed in September 1918. Florida was not among the 35 states that ratified the 19th Amendment in 1920.

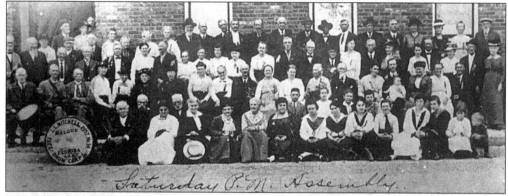

Members of the G.A.R. Post 34 assemble with their families for this 1915 photo. The efforts of the veterans in the early 1900s drew 4,000 new residents, many of them veterans, to St. Cloud. This photograph was taken on the south side of Eleventh Street beside the G.A.R. Hall. The auditorium on the ground floor and the upstairs meeting rooms were gathering spots every Saturday.

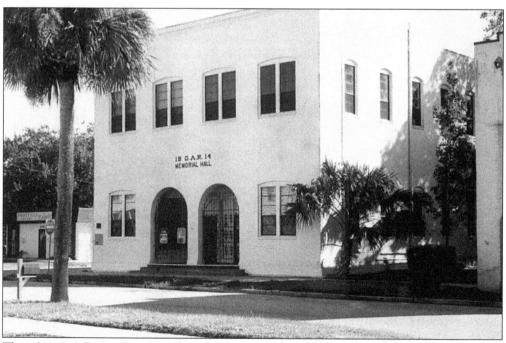

The 1914 G.A.R. Memorial Hall on Massachusetts Avenue provided an auditorium on the ground floor and upstairs meeting rooms for Post No. 34 of the Grand Army of the Republic.

The northwest corner of the G.A.R. building includes two historic markers. The smaller one recognizes its entry on the National Register of Historic Places. The larger honors the efforts of the L.L. Mitchell Post #34 of the G.A.R. and the Women's Relief Corps #12 for their efforts to build the G.A.R. Hall.

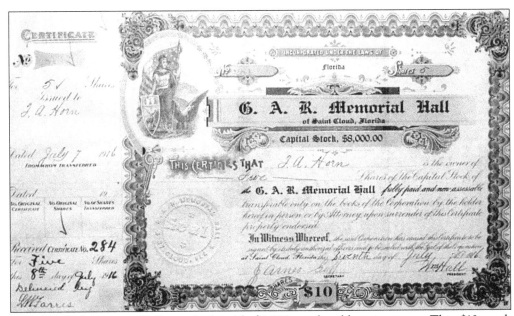

The G.A.R. Memorial Hall was built with $8,000 stock sold to investors. This $10 stock certificate for five shares was issued to T.A. Horn on July 7, 1916.

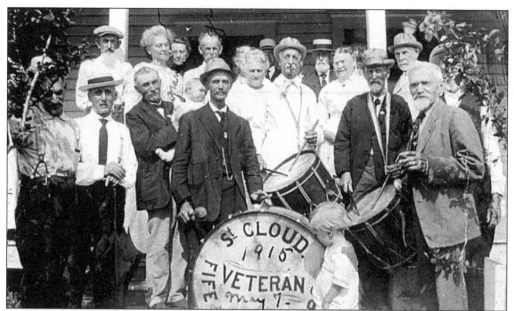

In the spring of 1915, these founding members of the St. Cloud Veteran Fife and Drug Corps pose with their wives before one of their many performances at parades and community gatherings. This photograph also is on the book's cover.

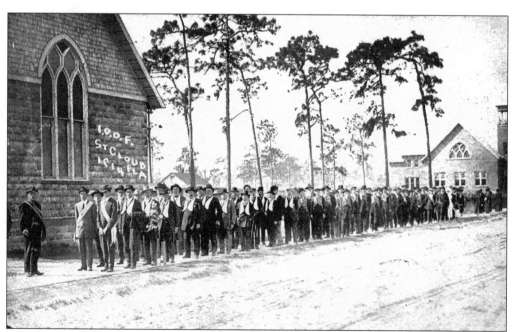

The Odd Fellows Day Parade was photographed at the Presbyterian Church on Tenth Street in about 1914.

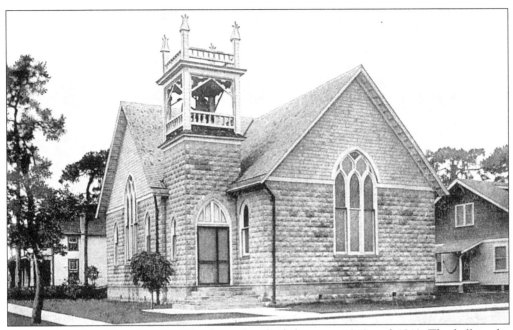

The Presbyterian Church at St. Cloud was first built between 1909 and 1910. The bell in the tower was the same one used at the Disston plantation. It was donated as scrap metal during World War II.

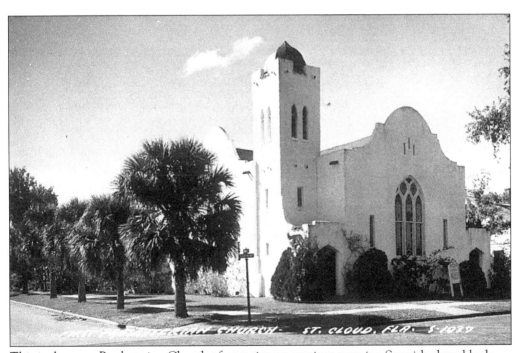

This is the same Presbyterian Church after major renovations gave it a Spanish chapel look.

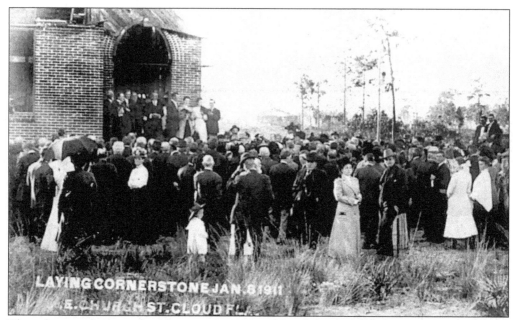

This photograph was taken January 8, 1911, at the dedication of the cornerstone for the Methodist Episcopal Church and parsonage.

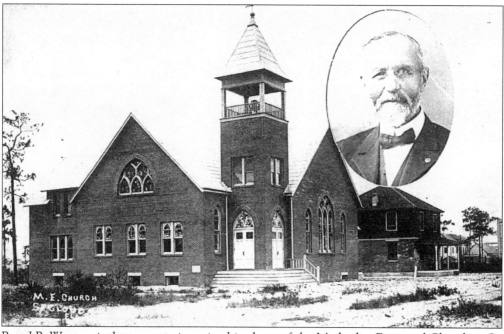

Rev. J.B. Wescott is shown as an inset in this photo of the Methodist Episcopal Church at St. Cloud soon after it was completed.

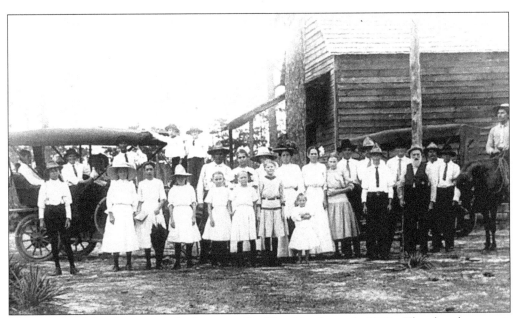

This Sunday School outing took place near St. Cloud in the early 1900s. The church group is not identified.

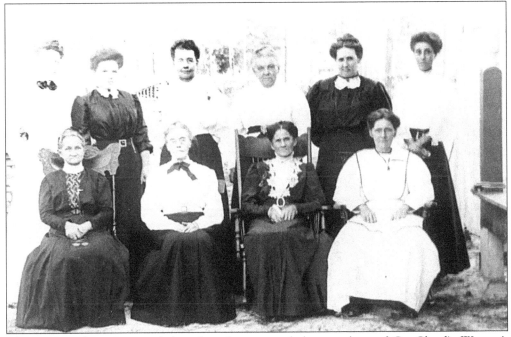

This group of women are believed to be some of the members of St. Cloud's Women's Improvement Group.

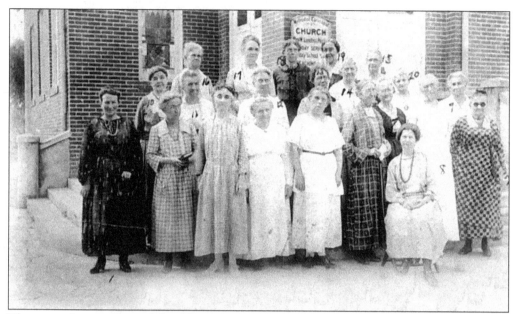

These are the members of the Women's Foreign Missionary Society of the First Methodist Church in St. Cloud. The society was the main women's group for church members. Mrs. L.U. Zimmerman, who ran a dry goods store with her husband, is shown seated on the right.

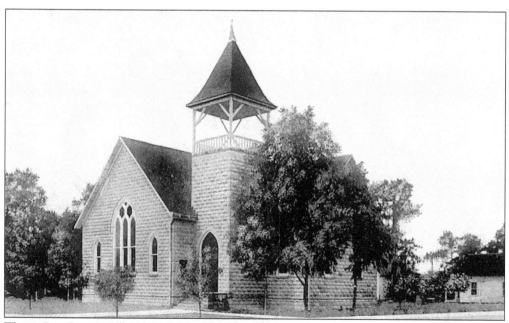

This is First Baptist Church on Massachusetts Avenue.

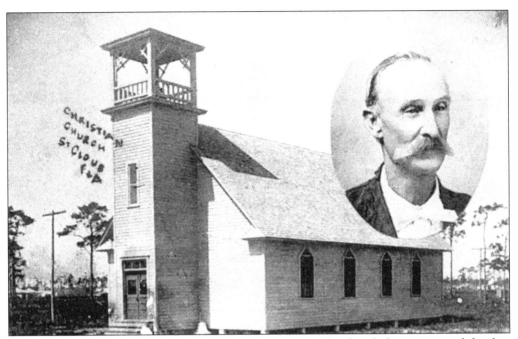

This 1911 postcard of the First Christian Church in St. Cloud includes an inset of the first pastor, Rev. M.P. Julian, one of the early veterans.

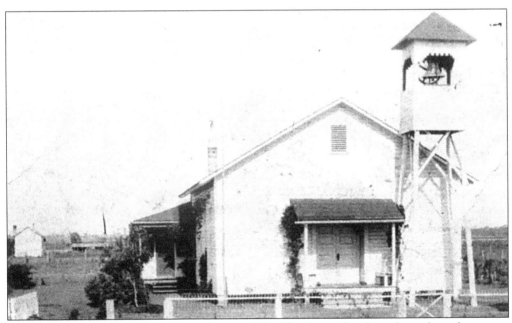

Reverend Brown's Chapel was located west of St. Cloud on what has always been known as Brown Chapel Road.

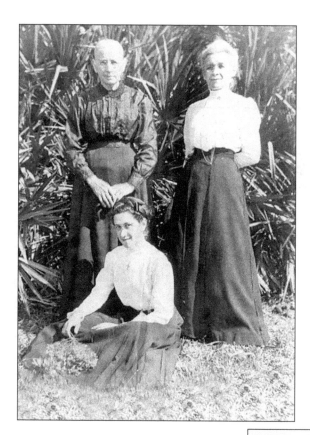

These women from St. Cloud are dressed for the summer climate.

Henry and Reuben Libby stand in an orange grove. Reuben Libby's first winter in Florida was in 1883. He enjoyed getting away from the bitter cold of Maine. He became one of the first Osceola County taxpayers to start paying off the bonds voters had narrowly approved in March 1889 to raise $30,000 to build a courthouse.

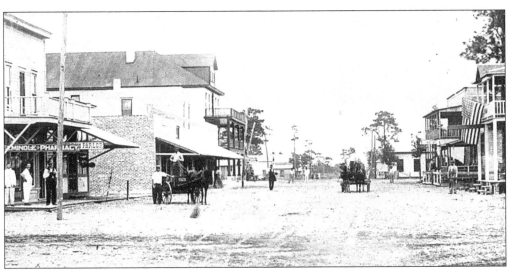

New York Avenue is shown looking north from Eleventh Street. The Seminole Pharmacy and a parlor are on the left. St. Cloud's horse and buggy days would soon end.

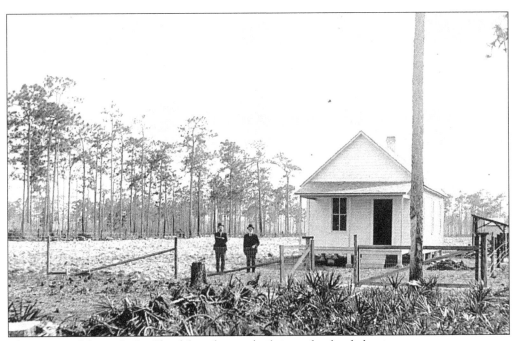

This is one of the early St. Cloud farm houses built just after land clearing.

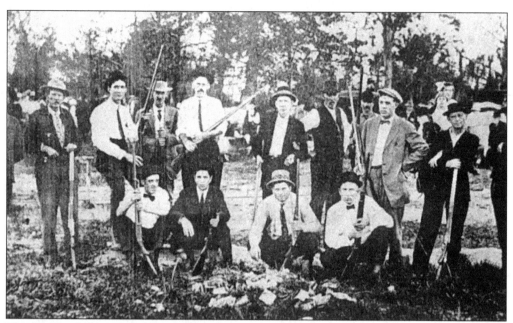

The St. Cloud Gun Club poses for this photo, c. 1910–1912.

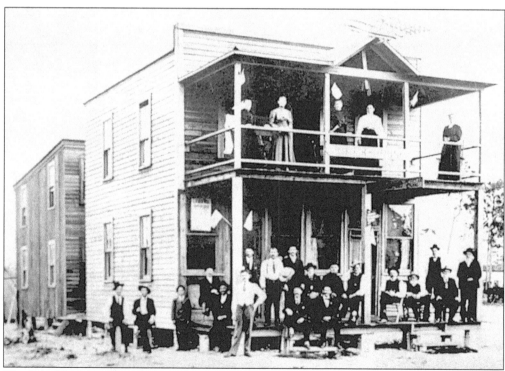

The Pifer House on New York Avenue is shown about 1911.

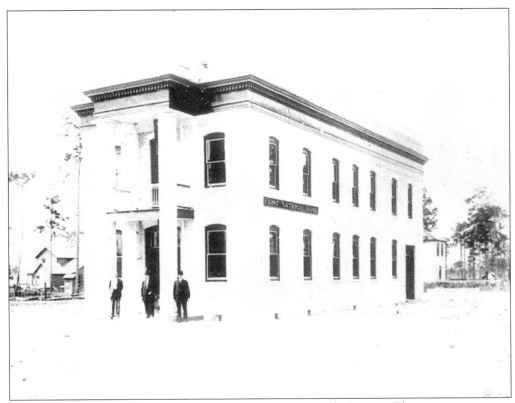

St. Cloud's First National Bank opened in 1910 on New York Avenue. The narrow, two-story buff brick structure was the only national bank in the county when it opened. It later served various veterans and civic groups.

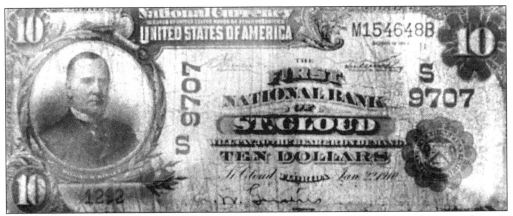

The First National Bank of St. Cloud issued this $10 note in 1911. Pictured on the front is William H. Lynn, the bank's first president.

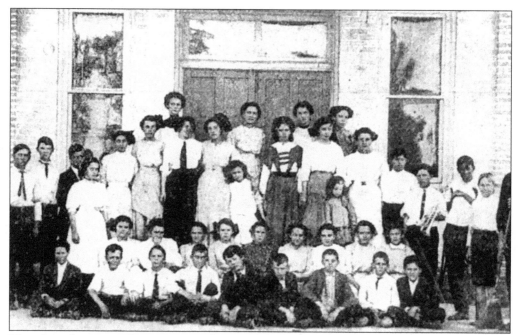

This class photo was taken in 1911 in front of the St. Cloud school. Many of these children are the grandchildren of the early St. Cloud veterans.

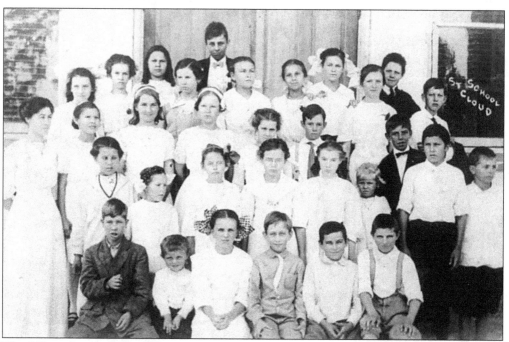

The fifth and sixth grade classes of 1912–1913 are shown at the St. Cloud School.

82

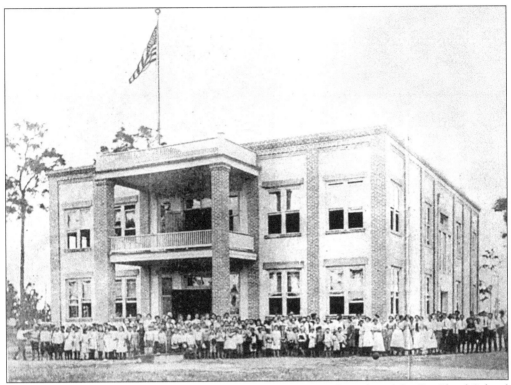

The *National Tribune* published this photo of the students and faculty of the St. Cloud School on December 19, 1912.

In this photo, Jessie Harris and family stand outside their home located at Georgia Avenue and Fourteenth Street.

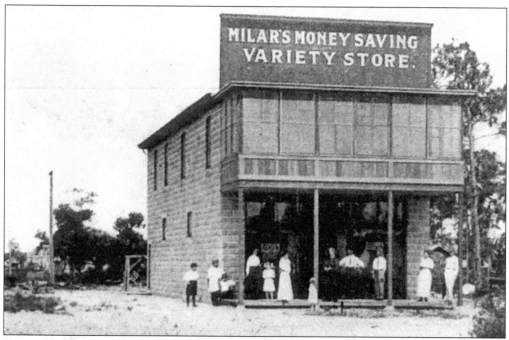

Townspeople gather outside the Milar's Store on Massachusetts Avenue and Eleventh Street in 1911. C.E. Carlson rented the downstairs space in 1915 for a funeral home.

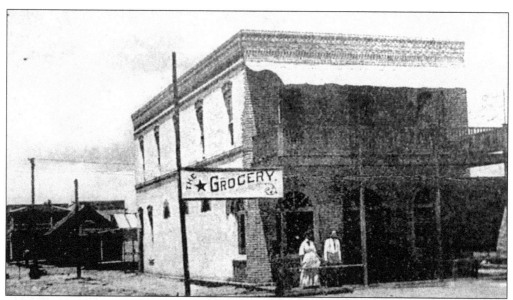

This 1911 scene shows Penn's grocery store on Pennsylvania Avenue at Eleventh Street. The St. Cloud telephone exchange would soon move into the second floor space.

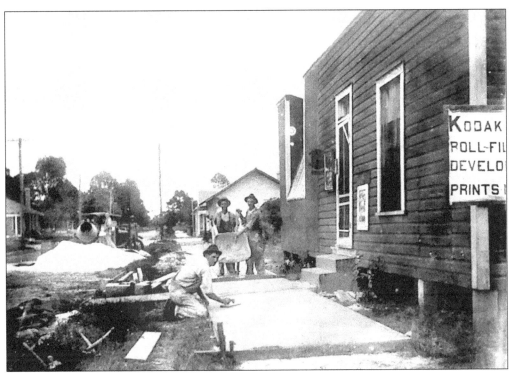

Workmen pour concrete for the sidewalk in front of the Kasbohm Studio.

Residents gather for a group photograph in 1913 on the porch of this rooming house on the eastside of New York Avenue between Tenth and Eleventh Streets. The site later became the Hunter Arms Hotel.

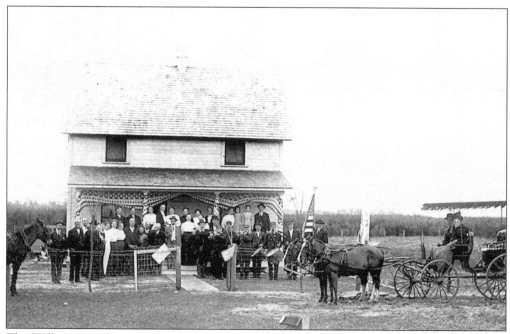

The William Wood residence, located along the lakeshore at Old St. Cloud, is decorated for a patriotic celebration.

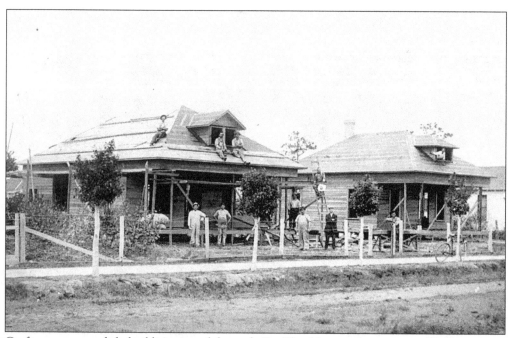

Craftsmen pause while building two of the early St. Cloud houses for veterans. The houses are at 608 and 612 Pennsylvania Avenue.

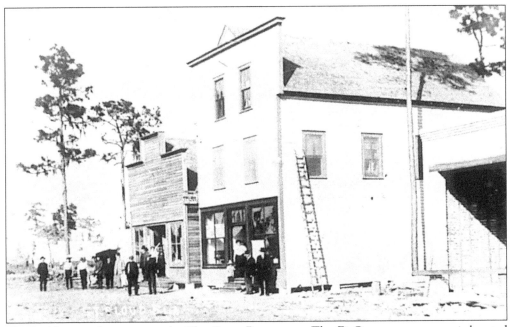

The building in the center is the Blue Front Restaurant. The DeGraw grocery story is located on the left.

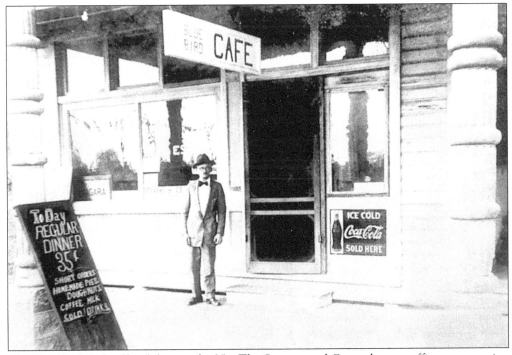

The Blue Bird Café offered dinners for 35¢. The Stevens and Co. real estate office was upstairs.

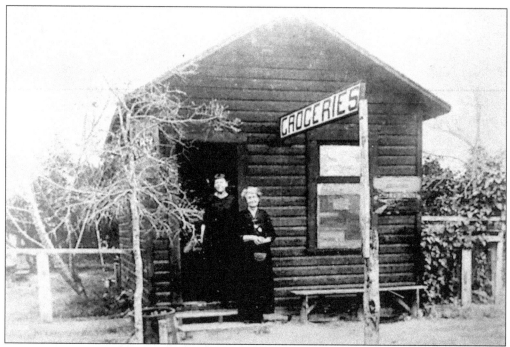

The Coles grocery store was on Eighth Street between Ohio and Indian Avenues.

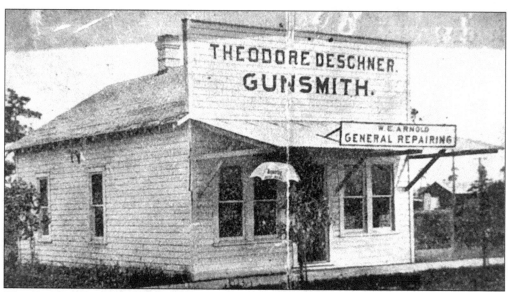

Theodore Deschner owned a gunsmith stop in St. Cloud. Repairs were made by W.E. Arnold.

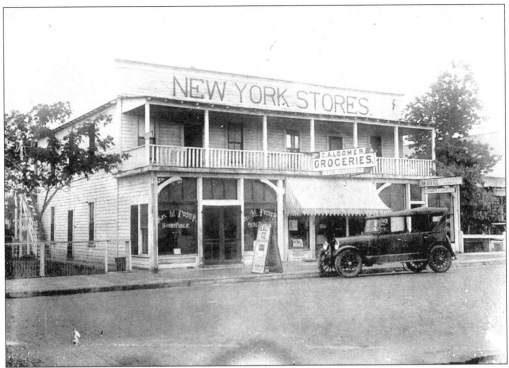

Mrs. M. Foster ran a notary public and real estate office on one side of the C.A. Loomer Grocery within the New York Stores building. The Parker & Parker law office was on the other side of the grocery. The town's chamber of commerce also shared this site, which today is the parking lot of the Hunter Arms Hotel.

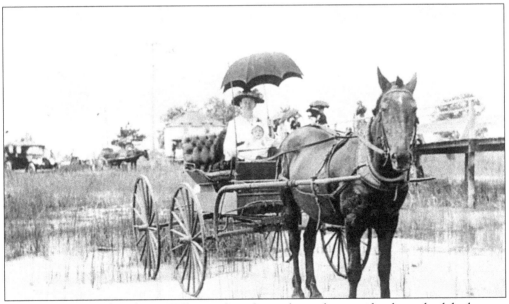

Mrs. William Wood and son William take a horse-drawn buggy ride along the lakeshore at Massachusetts Avenue.

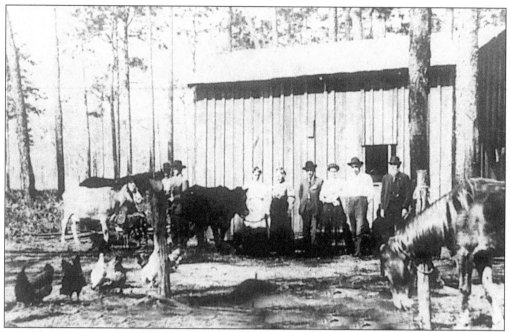

St. Cloud's first dairy is shown here. The man on the right is said to be Mr. Peckman, the owner, next to Walt Tyson.

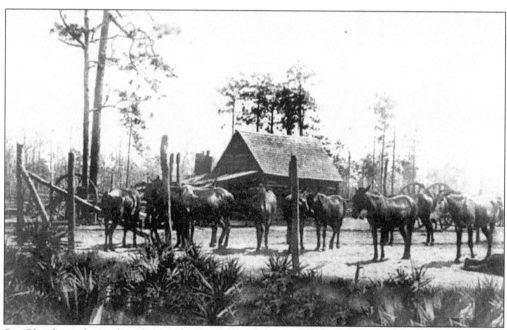

St. Cloud's mule yard and feed shed was located on the site of what is now Veterans' Park between New York and Pennsylvania on Thirteenth Street.

Shown are Thomas Nathaniel Farr Jr., who ran the St. Cloud plantation's commissary, and his daughters, Annie, Elinor, Katherine, and Abbie in 1920. Farr's wife, Ethel, ran plantation's post office.

A man and a boy hold the reins of two horses along a dirt road on the outskirts of St. Cloud. The town started in the era when horses were still the most reliable transportation.

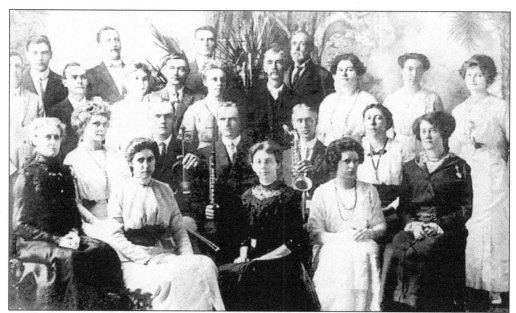

Men and women of the Methodist Church Choir gather before a performance in 1914. This large choir is one of the examples of the well-attended churches of the early years in St. Cloud.

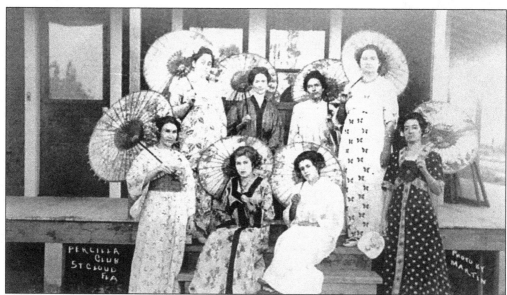

The Percilla Club of St. Cloud gather for a group photo in 1913. From the left are Cora Anderson Clark, Mattie Wilson, Mary Thorndylee, Jan Warner, Della Sage, Bessie Meatyard Daniels, and Eva Wilcox.

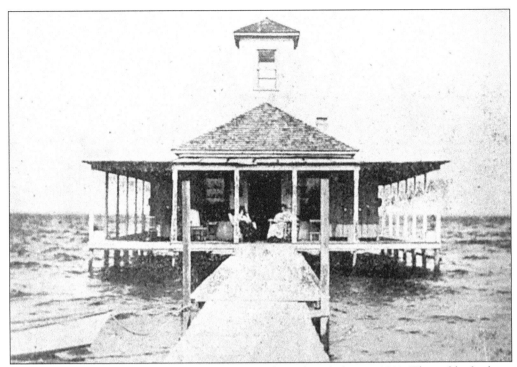

These two scenes show the boathouse on East Lake Tohopekaliga in 1912. The public bathing pavilion was one of the most popular spots on the lakefront. All three of the boathouses built along the waterfront in the early 1900s were lost to fires.

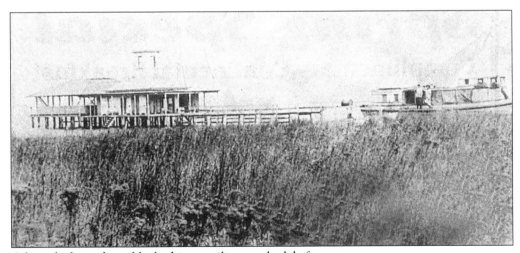

A boat docks at the public bathing pavilion on the lakefront.

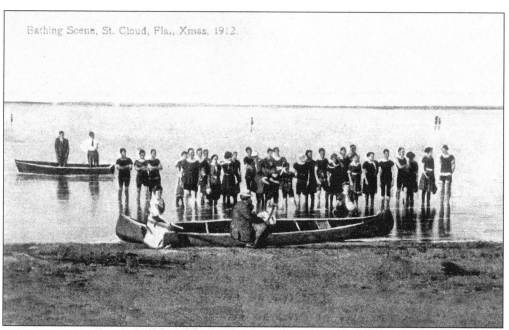

Bathing Scene, St. Cloud, Fla., Xmas, 1912.

The East Lake Tohopekaliga shore was the scene for this Christmas 1912 photo, taken so that family members could show off their bathing costumes for relatives back home that winter.

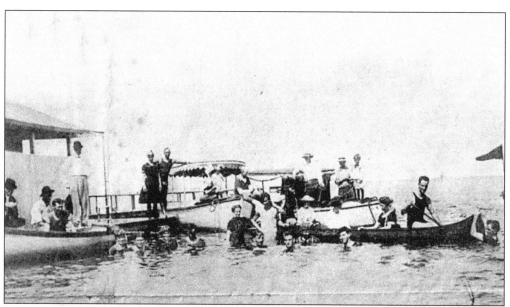

Canoes and other boats are shown at the lakefront pavilion in this 1912 photo. This photo appeared in advertising published to promote St. Cloud in the National Tribune.

Five

REBUILDING AFTER THE FIRE OF 1917

At sunrise on an early August Saturday in 1917, the smell of fresh-baked bread filled downtown St. Cloud with an air of rebirth. The reopening of the bakery meant St. Cloud's entrepreneurial spirit had survived a cloud of smoke and doom. A week earlier, a suspicious midnight fire destroyed boom-town businesses and wood-frame apartment houses. The town directed its attention to rebuilding, this time bigger, better, and safer with concrete, brick, and fire-resistant roofs. Days after volunteers joined forces to salvage goods before flames reached the stores and line bucket brigades from nearby wells to douse the last flames, local newspapers boasted of the town's determination to rebuild and recounted the extraordinary efforts of the tired townspeople. The first sign of renewal came when the Lippincott Bakery reopened in a makeshift store, selling "savory bread and delicious cakes and cookies," according to a newspaper report of the time. Two grocery stores had burned to the ground, but ranchers and farmers opened for business with fresh meat, vegetables, and fruits spread on open-air tables or the beds of their wagons. The owners of the gutted Palm Theater pitched a tent to show movies on the movie house's salvaged projector. And, as townspeople hauled away the burned debris, merchants prepared newspaper advertisements about their plans to reopen furniture and hardware stores and restaurants, and others announced plans to open additional stores. "The ruins had not cooled before plans for rebuilding were underway," the August 3, 1917, Kissimmee Valley Gazette reported.

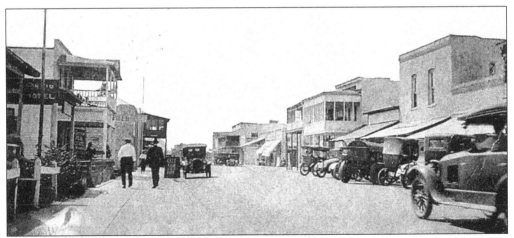

The New York Avenue business district is shown after the rebuilding following the Great Fire of 1917.

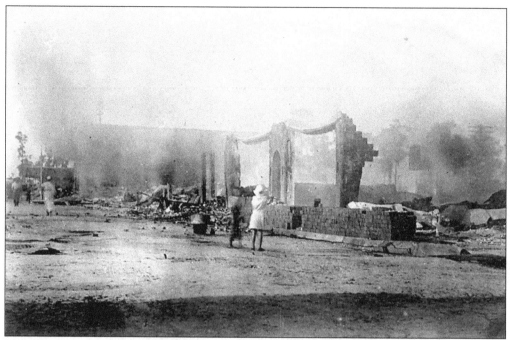

The ruins from the Great Fire of 1917 are still smoldering in a photo that shows two girls. The town's fire whistle sounded the alarm just after midnight July 28. A fire in a storeroom kindled blazes in adjoining pine buildings. Residents in second-floor apartments over the downtown store where the fire began had to dash to safety.

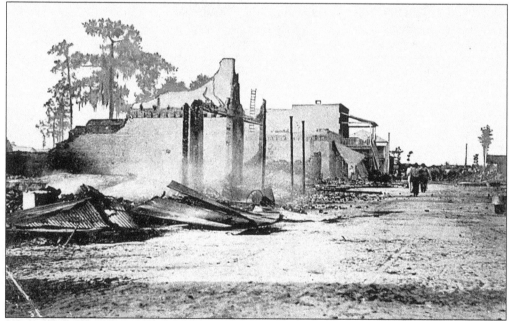

This view of St. Cloud after the Great Fire of 1917 shows the charred ruins along Pennsylvania Avenue. Many apartment tenants were still in nightclothes when they escaped. Firefighters arrived to see two-story flames lighting up the night sky and frantic merchants trying to save their stock. Townspeople were shocked but determined to rebuild.

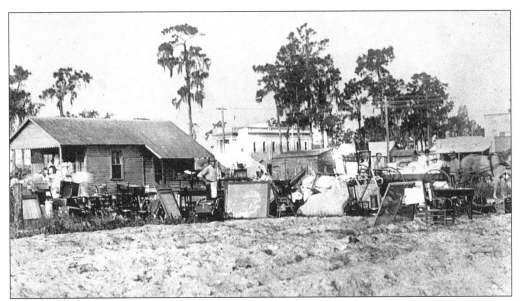

In this photo, residents examine the furniture rescued during the fire. The First National Bank of St. Cloud is in the background. Firefighters had relied on car after car of volunteers to haul buckets of water from wells. Leaping fires swept through the businesses and several apartment houses along both sides of Pennsylvania Avenue between Tenth and Eleventh Streets. News reports make no mention of serious injuries or deaths. The fire's toll, though, was high, estimated at more than $100,000 at a time when a city lot cost $100 and a train ride from St. Cloud to Kissimmee was 10¢.

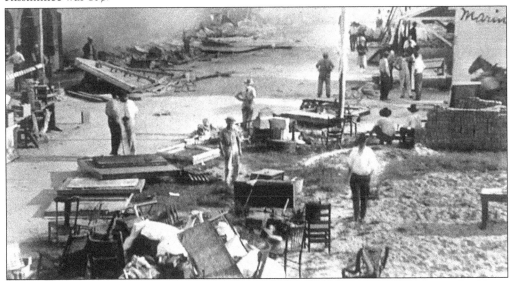

St. Cloud residents, many of whom took part in rescuing furnishings from the burning buildings during the Great Fire of 1917, gather to assess the damage. The fire gutted the post office, but not before people saved most of its contents. Townspeople carried canned goods out of a burning grocery to a vacant lot across Pennsylvania, but the heat from the blaze set the labels on fire. Afterward, they couldn't tell what was in the cans. Firefighters and townspeople also saved about half the stock at Hartley's Hardware before flames drove them from the building. The store would reopen and remain under the same family for four decades.

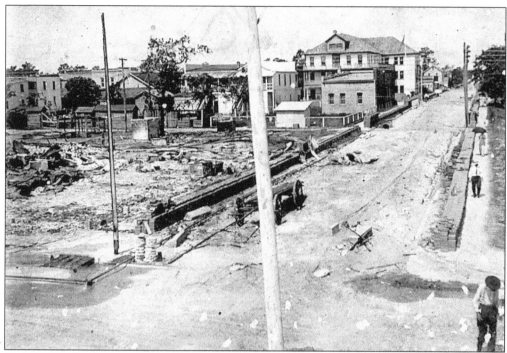

St. Cloud residents walk solemnly along the Tenth Street where the ruins of burned-out wooden buildings have been cleared. The second St. Cloud Hotel, built of brick after a fire in 1909 destroyed the original wooden hotel, can be seen in the background. Both sides of Tenth Street are lined with bricks for streets. The street paving—part of the road to Melbourne—was planned before the fire. Arson was suspected as the cause of the fire. Three suspects were indicted, but a judge threw out the cases. The mystery of the fire was never solved.

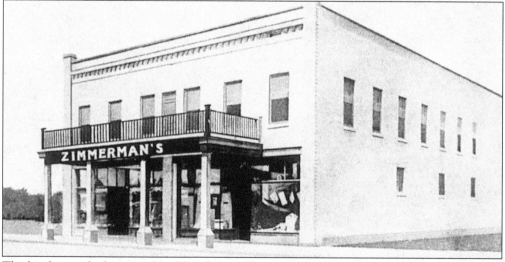

The big fire sparked a second building boom. This is the Conn Building, shown in 1917, at the northeast corner of Tenth Street and Pennsylvania Avenue. L.U. Zimmerman's store opened in this building, an example of the bigger, better, and safer buildings made with concrete and brick and fire-resistant roofs. Most of the pre-fire structures had gone up quickly and cheaply during the hurry-up boom times.

98

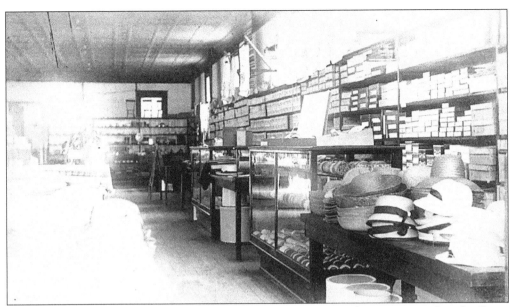

These two interior views show L.U. Zimmerman's store in 1917. The store opened in the Conn Building on the northeast corner of Tenth Street and Pennsylvania Avenue. In 1933, the store moved to New York Avenue. It was sold in 1952. The October 19, 1917 issue of the *Gazette* carried this optimistic report regarding what was to come: "The outlook is for more buildings and better buildings, and as has always been the case after a sweeping fire of this character, the quality will outclass the old structures and the city will be a great winner while the unfortunate property owners are losers."

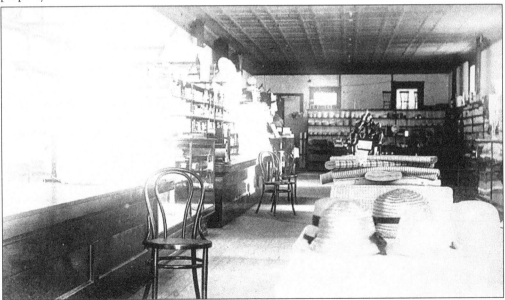

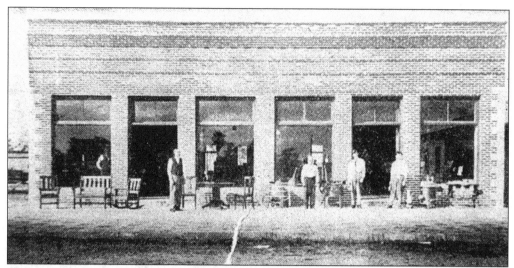

This is the Makinson's Hardware Store on New York Avenue after its new brick building was completed after the 1917 fire. The antique mall shops along New York Avenue today are in the former Makinson store. The family-owned business is Osceola County's oldest business and the state's oldest hardware store.

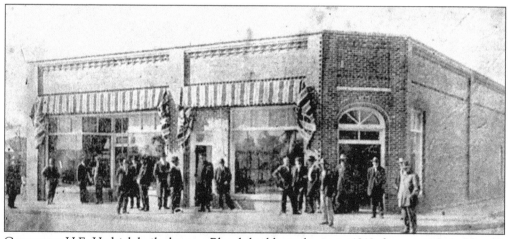

Contractor H.E. Hedrick built the new Bleech building, shown in 1918, for owner G.A. Bleech's grocery at the southwest corner of Tenth Street and Pennsylvania Avenue. The building includes the Bleech grocery and the Edward Brothers gentlemen's clothing store.

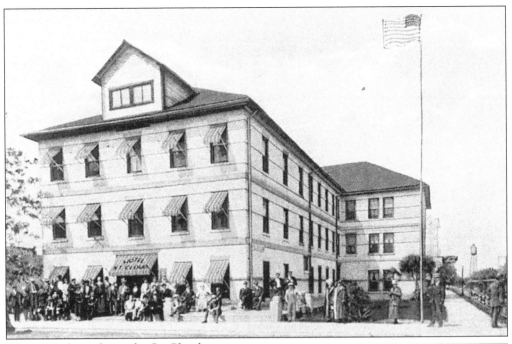

This 1927 photo shows the St. Cloud Hotel was still the centerpiece of the downtown area. Note that the porches from the original building have been removed. Streetlamps are in view along the right side.

SAINT CLOUD
Florida

THE
WONDER
CITY

A Book of Facts

Issued by the St. Cloud Chamber
of Commerce

ON EAST LAKE TOHOPEKALIGA—ST. CLOUD, FLA.

The St. Cloud Chamber of Commerce featured this pavilion on the front of an early 1920s brochure that promoted the town to tourists.

101

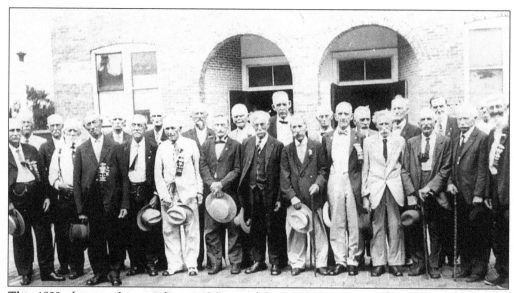

This 1929 photograph was taken on Memorial Day and shows members of the Grand Army of the Republic veterans. Some were among the first to buy home sites and farmland sold by the veterans association. In the background is the G.A.R. Hall, which served the veterans and remains in use as a museum.

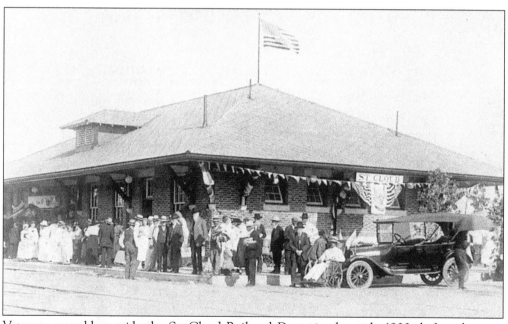

Veterans assemble outside the St. Cloud Railroad Depot in the early 1900s before the start of a Memorial Day parade. Veterans later purchased the depot, which remains a downtown veterans' post.

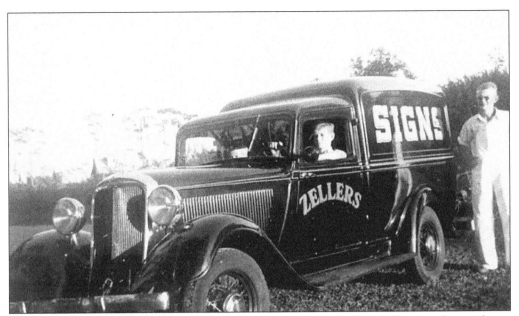

Charles Zellers is at the wheel of the family's sign business truck. Don Zellers stands outside.

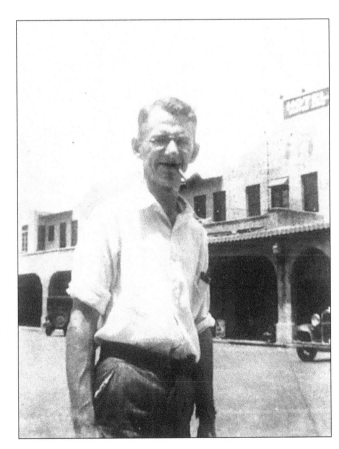

Don Zellers stands on New York Avenue outside the Hunter Arms Hotel. Zellers, who owned a sign business, owned the *St. Cloud News* in the 1940s. The paper was founded by Edward Parradee, the mayor in the early 1930s who wanted a different political voice than that offered by the *Tribune*.

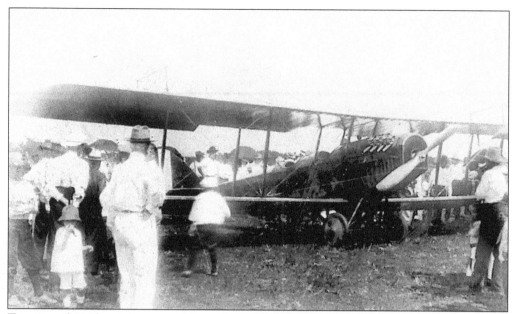

Townspeople gather to inspect a plane after it landed at the St. Cloud airstrip between North Orange and Rosedale Avenues.

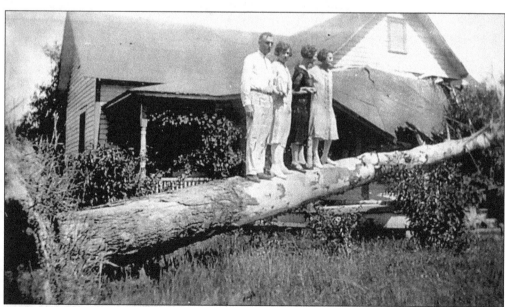

A hurricane in 1926 knocked down trees throughout St. Cloud. Dana and Louise Eiselstein and Stella Gessford stand on one of the downed tree trucks. The house is at Thirteenth Street and Kentucky Avenue.

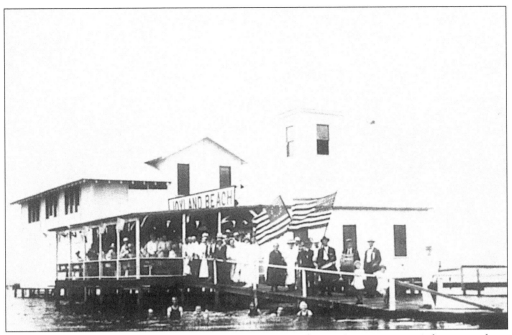

The Joyland Beach pier and dance hall, shown on July 4, 1921, was a popular spot along the lakeshore at Ohio Avenue after fire destroyed the public bathhouse and pavilion owned by C.E. Carlson.

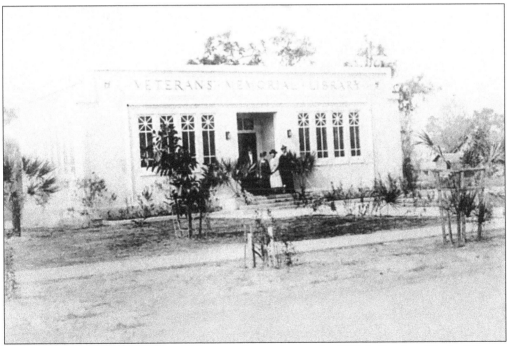

The St. Cloud Veterans' Memorial Library is shown during the 1925 dedication. The building at Massachusetts Avenue between Tenth and Eleventh Streets is now the Woman's Club.

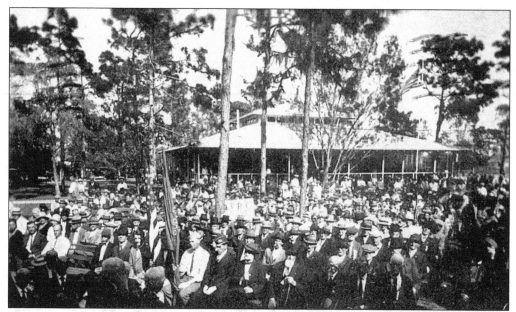

This postcard, mailed from St. Cloud in 1938, shows the Tourist Park clubhouse during a veterans celebration.

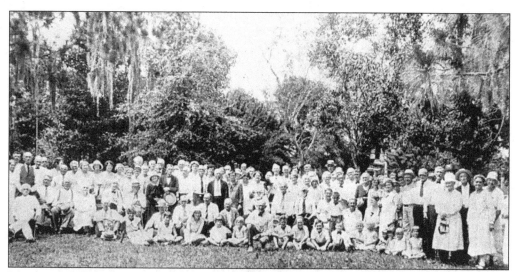

Members of the Grand Army of the Republic, their wives, children, grandchildren, great-grandchildren, and friends pose during a July 4, 1931, picnic at Tourist Park in St. Cloud.

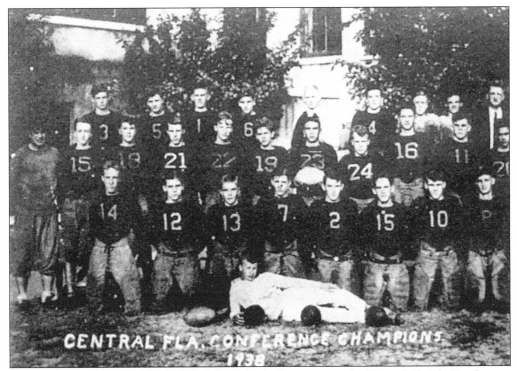

The members of the St. Cloud High School football team were the Central Florida Conference champions of 1938.

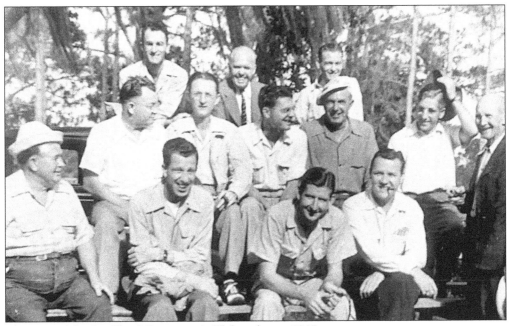

The men of the St. Cloud Sportsman's Club gather in 1945.

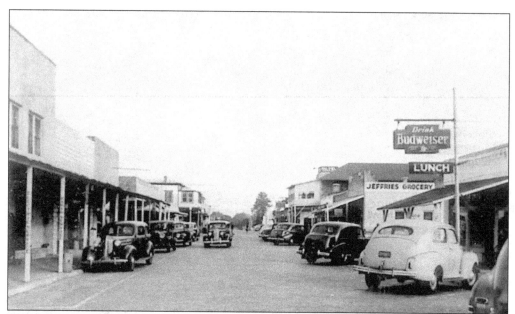

The cars in this 1947 scene of downtown St. Cloud's business district help identified this era.

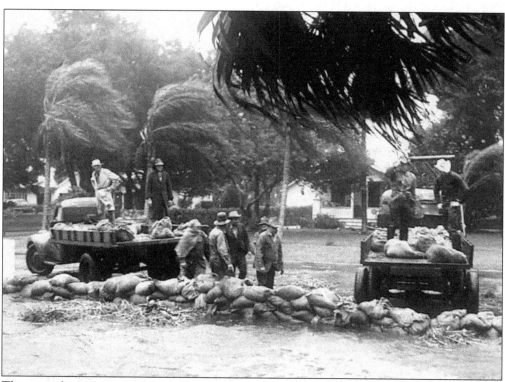

This view shows crews sand-bagging near the bathhouse during Hurricane Hazel on October 9, 1953. High winds pushed water along East Lake Tohopekaliga into the bathhouse.

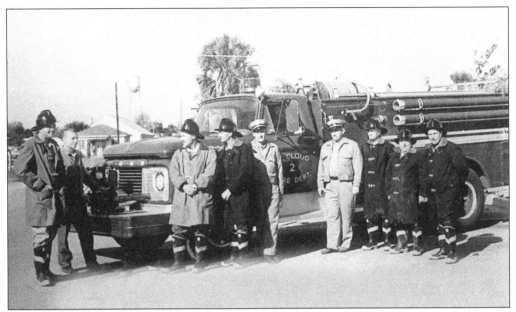

In 1964, St. Cloud's firefighters were proud of their new fire truck. Chief Donald Prickett stands on the far left with the man who delivered the truck. The others, from left to right, are Francis Harden, Pat Daugherty, Chris Henderson, Adlai Peed, Charles Jolley, James Adanolfi, and Horace Dean.

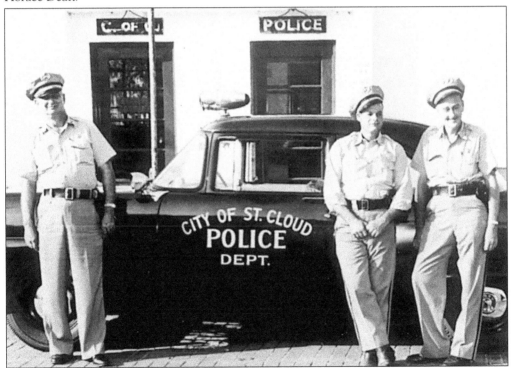

St. Cloud Police Chief Bud Yarger, left, with officers Dana Mapes and Hugh Rummel, are pictured in front of the building at New York Avenue and Tenth Street that served as the chamber of commerce and the police department in the 1950s.

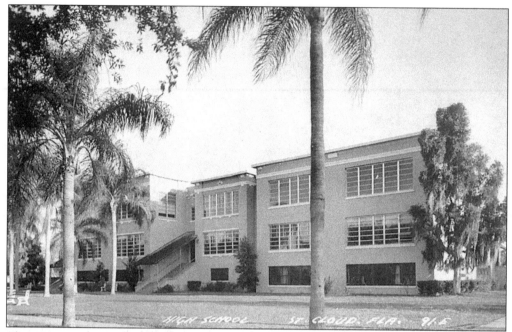

This is St. Cloud High School after the addition for the west wing was completed in the 1940s. The principals in the decade were A.F. Swapp, 1940–1946; William J. Woodham, 1946–1948; and Homer L. Jones, 1948–1950.

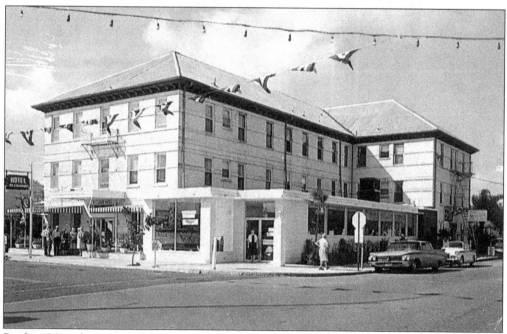

By the 1960s, the ground-floor restaurant space had been added to the St. Cloud Hotel.

Six

THE ENGLISH COLONIES AT NARCOOSSEE AND RUNNYMEDE

Several communities near St. Cloud are older than the veterans' colony. Of these, the English colonies at Narcoossee and Runnymede have had the greatest impact on the area's history. Many residents were Englishmen with too many older siblings to inherit family estates, so they set off to live abroad. In the 1880s, Florida's railroads ran advertisements in London newspapers about vast interior lands available for ranchers, citrus growers, and sugarcane, cotton, and rice planters. J.C. Stratford, youngest son of an English noble, was typical of the youthful colonists. Stratford became a steamer captain, salvaging the steamer Tallulah *from the bottom of Lake Kissimmee and renaming her the* Reindeer. *Others came as laborers and servants for retired professional and government officials and army officers. They built tennis courts and polo grounds. One of the English farmers, E. Nelson Fell, encouraged others to come to Florida; he built his estate at Fell's Cove on the extreme northeast shore of East Lake Tohopekaliga and became one of Osceola's early county commissioners in 1887. The residents at Runnymede lobbied for their town to become the county seat, but that honor went to Kissimmee.*

These men are two of the early residents of the English colony at Narcoossee. The Narcoossee Riding Club and the Runnymede Hunt Club were important parts of the English social circle. The Runnymede Hotel ran a Lawn Tennis Club. The British also brought their love for polo, with a team being organized in 1888 and having more than 100 members within two years. The club, later affiliated with the American Polo Association, built polo grounds in Orlando.

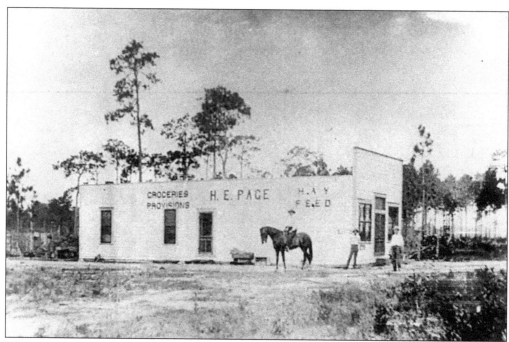

This is H.E. Page's grocery store at Narcoossee. One of the English settlers opened a store at Narcoossee, hauling merchandise by ox team from a steamboat landing at Lake Tohopekaliga. Other English settlers built the steamboat the *Colonist* in 1885 and used it to haul cargo until the Sugar Belt Railroad line reached Narcoossee from Kissimmee.

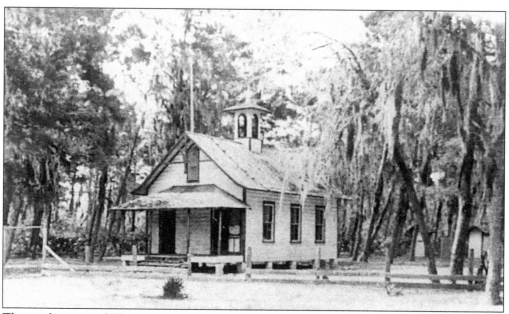

This is the original Narcoossee School, which also served as a church for the early English settlers. It was later used for the chamber of commerce and then by the volunteer firefighters.

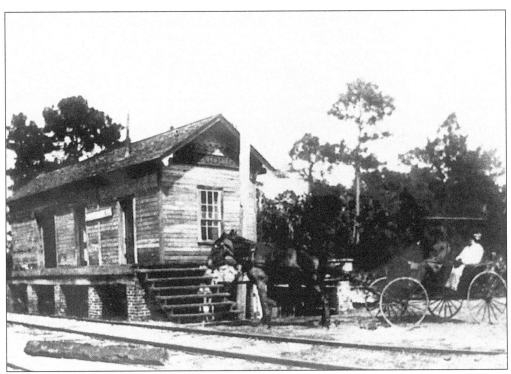

W.G. King, the Grand Army of the Republic Association's agent sent to set up the veterans' colony at St. Cloud, sits at the reins of this horse-drawn buggy at the railroad station at Narcoossee. Working with the veterans' Seminole Land and Investment Co., King arranged for veterans to live at the Runnymede Hotel until their houses were completed.

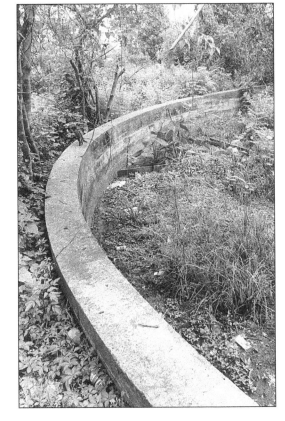

This concrete wall is all that remains of the railroad turn-a-round at Narcoossee. The Sugar Belt Railroad linked the plantation with the English colonists at Narcoossee and the steamboat wharfs and train depot at Kissimmee.

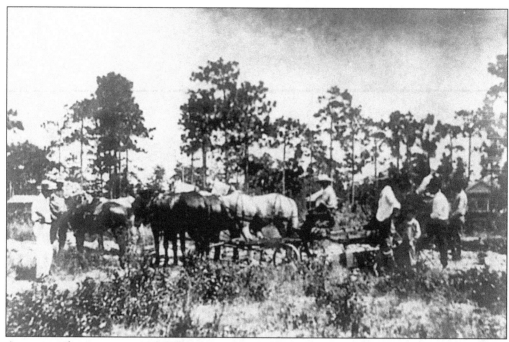

A crew grades a street at Narcoossee in 1914 to serve the small rural community northeast of St. Cloud.

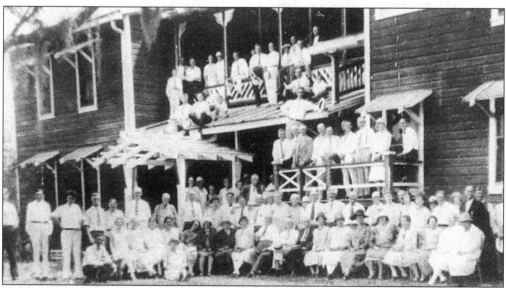

This group photo was taken in front of the Runnymede Hotel on East Lake Tohopekaliga. About 1885, settlers built this three-story wooden hotel approximately one mile west of Narcoossee on Lake Runnymede. Englishman Beauchamp Watson, who managed the hotel, catered to winter tourists from the North. His home and store were nearby. He also owned several other buildings.

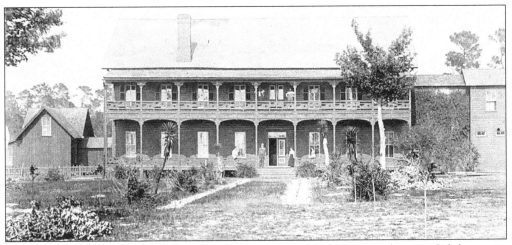

This is the front exterior of the Runnymede Hotel, named for the town where English barons in 1215 forced King John to grant civil and political liberties spelled out in the Magna Carta. The Florida Runnymede is near the lake of the same name. The hotel briefly served as an agriculture school, then reopened as a hotel. The Disston Drainage Co. used the hotel for a short time as its headquarters. The Runnymede Hotel would serve as one of the early gathering places for veterans who came to St. Cloud to buy houses and farmland.

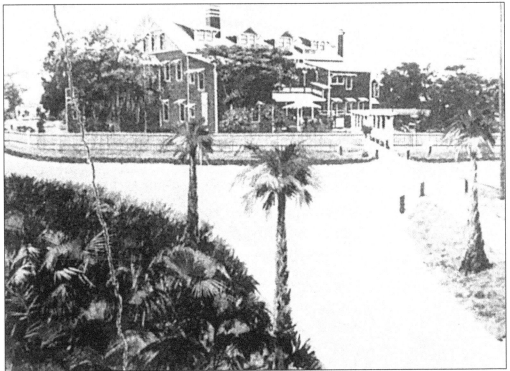

This scene shows the grand entrance to the Runnymede Hotel. Englishman Beauchamp Watson in the early 1900s started plans for an agricultural college at the hotel. The college never worked out, but Watson continued running the hotel's 35 guest rooms. The hotel, a nearby store, and several houses were called Wharton. The hotel thrived for a time, but it was abandoned during the Great Depression and later torn down.

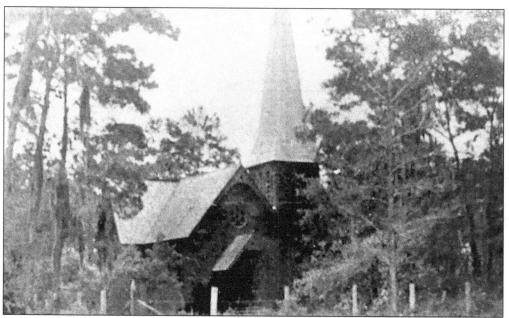

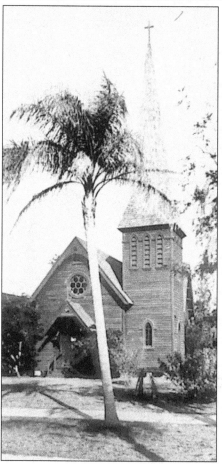

Both of these photographs show the Episcopal church after it was moved to Florida Avenue in St. Cloud from the English colony at Narcoosee. The 72-foot spire was added after the move. The church was built during very tough times in Florida. Hamilton Disston's empire was folding and back-to-back killer freezes during the winter of 1894–1895 had destroyed nearly all the orange groves in Central Florida. Some 200 colonists, half the population of the community, had given up and moved to cities or back to England. An Orlando bank failed, taking with it the $1,200 saved by Narcoossee residents for a community church. Still, those who remained were determined that their settlement would have an Episcopal church. The congregation, which had been meeting in a schoolhouse, had begun construction on their building in late 1892 or early 1893, but completion was delayed by the hard times. The colonists rallied with socials, concerts, and plays to raise money. Disston came to one of the occasions at the Runnymede Hotel. The Episcopal Church of St. Peter was completed in 1898 with wood brought by ship from England. In 1930, the church was taken apart, moved into St. Cloud, and attached to the Church of St. Luke on Florida Avenue, becoming the Church of St. Luke and St. Peter. In 1970, the church bought a site at Tenth Street and Illinois Avenue. This time, the church was moved in one piece to its new home four blocks away.

Seven

THE SHAKER COLONY, ASHTON, AND ALLIGATOR LAKE

The early followers of the United Society of Believers in Christ's Second Appearing, commonly called Shakers for their quivering movement while singing and praying, came to old Disston sugar plantation land to begin a new community where their faith could thrive. Best known for their elegantly simple architecture and furniture, the Shakers followed a communal lifestyle with little or no individual possessions or money. They practiced celibacy, pacifism, sexual equality, and community ownership of goods. Elder Isaac Anstatt in 1896 bought more than 7,000 acres from the Disston land company. At their Olive Branch colony southeast of St. Cloud, which included Trout Lake, Lake Lizzie, Live Oak Lake, Sardine Lake, and the upper portion of Alligator Lake, Shakers started several enterprises, including commercial fishing and pineapple farming. The Osceola colony never attracted more than a dozen members, many of whom came from other Shaker communities. The death of an ailing guest disrupted the colony.

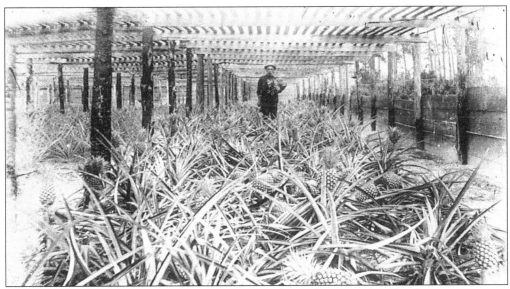

Pineapples grow under the shade in 1910 at the Shaker Colony near St. Cloud.

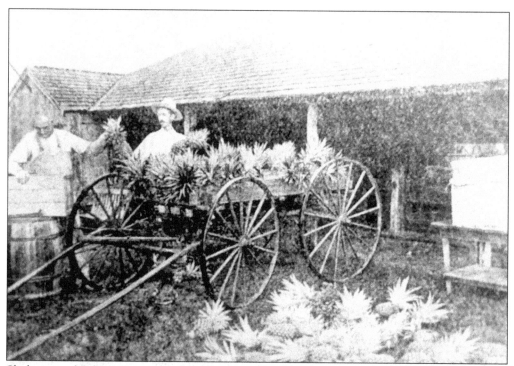

Shakers are loading pineapples for delivery to St. Cloud at the railroad depot. By the early 1900s, the Shakers were shipping pineapple plants to Cuba and selling up to 400 of their award-winning pineapples each week in Kissimmee. Pineapples once grew along the St. Johns River and as far south as the Keys. In the late 1870s, most settlers had pineapple patches.

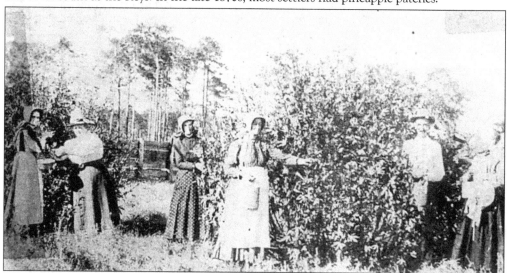

Women and men at the Shaker Colony pick berries. The colonists accepted into their care Sadie Marchant, who had been treated at a tuberculosis sanitarium at Narcoossee. Penniless, expecting to die within a few months, and unable to return to her Rhode Island home, she turned to the colony, which took her in. She lived under the Shakers' care for six years. Often in intense pain, she attempted suicide several times. Finally, she asked the Shakers to help end her pain. She died August 20, 1911, from the effects of two lethal doses of chloroform.

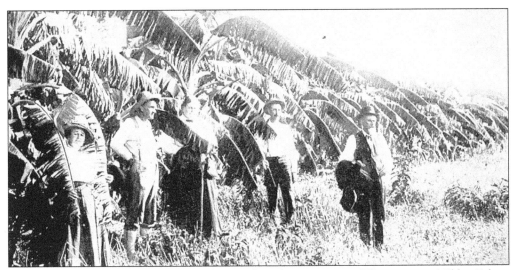

Members of the Shaker Colony stand near their banana grove. The arrests of Elder Egbert Gillette and Sister Elizabeth Sears for the death of Sadie Marchant sparked debates in newspaper reports from New York, Boston, Cleveland, Cincinnati, and elsewhere. Community leaders and newspapers rallied to support the Shakers. A grand jury refused to indict the pair in the mercy killing, but a state prosecutor pressed hard. Still, five months after Marchant's death, the Shakers were cleared of criminal charges. Gillette left the colony and the Shakers slowly sold their land or lost it in tax auctions as the state and national economies collapsed in the late 1920s and early 1930s.

Gerald Ashton, shown here, and his brother Frank, are the namesakes of the community of Ashton, east of St. Cloud. For two decades, the Sugar Belt Railroad linked the sugarcane plantation at St. Cloud with the English colonists at Narcoossee and the steamboat wharfs and train depot at Kissimmee. It also stopped in Ashton. Whether its cars were hauling barrels of sugar to Kissimmee or returning Narcoossee settlers from dinner at the Tropical Hotel and an evening at the Kissimmee Opera House, the Sugar Belt's engine needed wood to stoke its boiler. Three miles south of Narcoossee, Frank Ashton stacked cords of wood in a large bin along the track. The area became known as Ashton's Woodrack, but maps today simply label the area, which is north of Live Oak Lake, as Ashton. Frank came to Florida from Lancaster, England, in 1883, just one year after his uncle had arrived. His brother Gerald followed in 1884. The Ashton family and their community survived along a different path once cars and trucks took away the profits from the railroads, Gerald Ashton later supervised Osceola County road building.

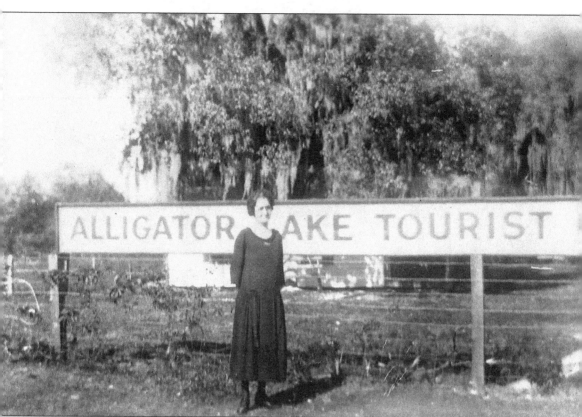

This woman stands in front of sign at the entrance of the Alligator Lake Tourist Camp east of St. Cloud during the early days of motorcar touring when travelers discovered the beauty of the 35 miles of shoreline at Alligator Lake east of St. Cloud. The lakefront was a popular spot during the era of Florida's tin-can tourists. Their cars are now antiques. Their roads no longer exist, except for a few rare miles of abandoned stretches. Named for the canned food they hauled in their makeshift trailers, Americans with moderate incomes discovered they could afford a Florida vacation by loading up their Fords with tents and camping and cooking gear. Their destination was never Palm Beach. They could never afford to travel in the luxury railroad coaches that carried the wealthy to Florida winter resorts along the coast. Instead, they found comfort from the sunshine at scattered inland auto camps. They were the first to combine the idea of home and auto, mobility and bedrooms, into a single entity. With canvas and wood, they converted their cars into crude travel campers, using their back seats for beds and their radiators for cooking. Tin Can Tourists descended on Florida in such numbers that cities created campgrounds to accommodate the influx.

Eight

THE SAWMILL TOWN
OF HOLOPAW

Florida's vast first-growth forests provided timber and turpentine profits during the late 1800s and well into the mid-1900s. Much of the land surrounding St. Cloud and deep into the forest wilderness had scattered sawmills, logging camps, and turpentine stills. The largest of these was built by J.M. Griffin in 1923. He picked Holopaw, southeast of St. Cloud, for a large sawmill that turned Osceola County's cypress and pine trees into lumber for the state's building boom. He built streets and housing for crews. Crews built a small mill to cut timbers for the larger mill erected north of the houses. Griffin brought in professional millwrights to build the mill and assemble its heavy machinery. The J.M. Griffin Lumber Co.—with one of the first all-electric sawmills in the country and one of the largest in the Southeast— had the biggest payroll in the county, employing more than 500 workers. Griffin's mill made Holopaw a thriving town for eight years, but the enterprise closed when Florida's boom times gave way to the Great Depression. Four years later, the Peavy-Wilson Lumber Co. of Louisiana opened a new mill, which provided employment for more than 1,000 turpentine, timber, and sawmill workers.

This stationary carries the letterhead for the Peavy-Wilson Lumber Co. Inc., which manufactured "virgin long leaf Florida dense pine and red cypress" at its Holopaw sawmill.

Shown is the Florida East Coast Railroad Depot at Holopaw, which was once a thriving sawmill and turpentine town. Beginning more than a century ago, the longleaf pine forests of the Holopaw area supplied a growing nation with "naval stores"—turpentine, rosin, pitch, and tar—used to make paint thinners and solvents, to preserve ropes and rigging on sailing ships, or to caulk and seal the seams between hull timbers. Musicians used their high-quality rosin for stringed instruments. Others used rosin for soaps, medicines, and a variety of other manufacturing purposes.

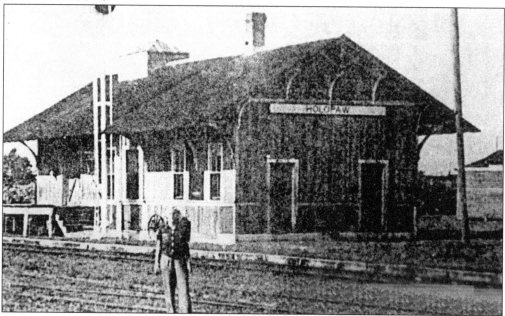

A well-dressed gentleman stands behind the Holopaw Hotel in 1927 when Florida's land boom of the 1920s kept the sawmill at Holopaw busy providing lumber for new buildings. Lumber from Griffin's Mill was used to build 300 houses. His carpenters also built a rooming house for families expected to arrive later. Griffin's commissary provided space for a drugstore, a dry-goods store, and a grocery. Griffin had a private office in a building that included the headquarters for his timekeepers, paymaster, and bookkeepers. Griffin also hired a company doctor and nurse. In what may have been one of the early cases of group insurance, Griffin kept a portion of each employee's pay to cover the cost of providing health care for the workers and families. The company-built church also served as Holopaw's first school for students through the eighth grade. The mill provided houses with electric lights and running water. An icehouse was built near the railroad tracks. The boom went bust just before the stock market crashed in 1929. J.M. Griffin ran into trouble coming up with the money to buy more timberland and operate the mill. It closed in 1931, forcing workers to abandon the town.

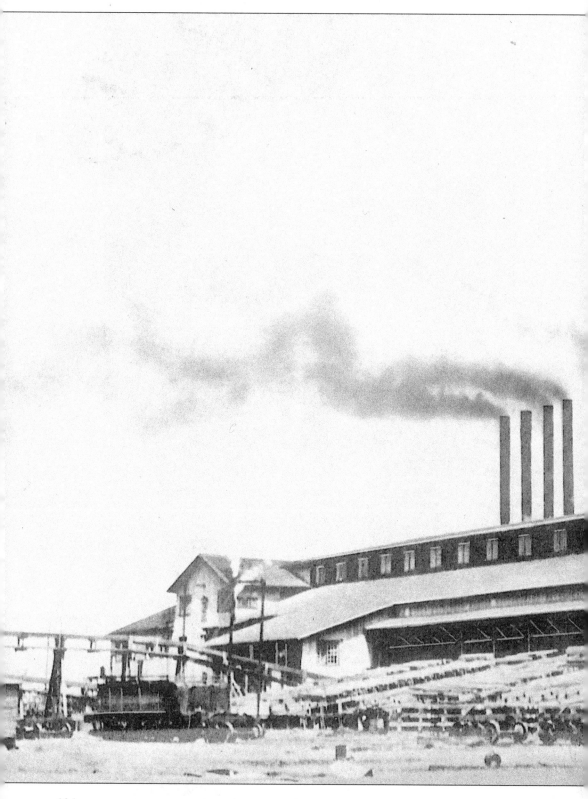

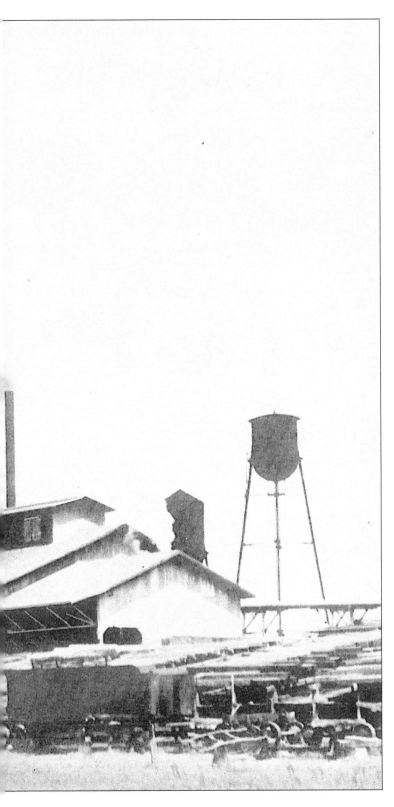

Peavy-Wilson Lumber Co. built the second of two major sawmills at Holopaw. The Griffin-built sawmill town had folded once the Great Depression took hold. The Peavy-Wilson turpentine and lumber company from Louisiana saved the mill town in 1935. The new mill provided employment for more than 1,000 turpentine, timber, and sawmill workers. When the mill's machinery was cranked up to saw its first logs, a newspaper told its readers, "scores of willing workmen now on the job" were assured "that better times had arrived in this section of Florida." Unable to find enough laborers in Florida, the company wrote contractors in Louisiana to round up crews, promising transportation, jobs, and housing. A trainload of 500 workers and some of their families soon arrived in Florida. The company provided "shotgun houses"—three to six rooms in a row.

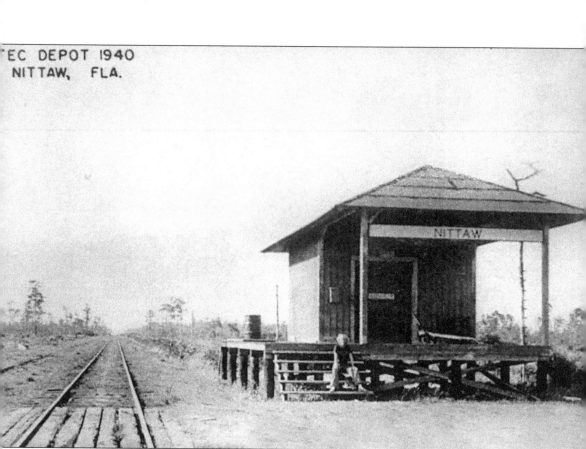

This is the Florida East Coast Railroad Depot at Nittaw in 1940. The depot was in the flat forestland south of Holopaw. By the 1940s, 70 years of turpentine and logging operations had stripped Florida of first-growth pines. After the pines dried up from the turpentine operations, loggers moved in, cutting every tree and replanting none. Once the logging stripped the land of pines, the ranchers, citrus growers, and farmers cleared out palmettos for cattle, groves, and fields.

EPILOGUE

Lucius L. Mitchell was the Union army private who became the first of the Grand Army of the Republic veterans to die after a soldiers' colony was established at St. Cloud. The post grew to be the second largest in the nation. Two veterans' organizations honor his name. The G.A.R. L.L. Mitchell Post No. 34 first assembled in St. Cloud in 1909. Later, the Lucius L. Mitchell Camp No. 4, Sons of Union Veterans of the Civil War also took the name of the Union private who brought his wife and five of their eight children to St. Cloud in 1909. Mitchell died later that year. He was buried at the Rose Hill Cemetery in Kissimmee. His gravesite remained a mystery until 1999 when family records revealed the burial record and his remains were moved to the Mount Peace Cemetery on the eastside of St. Cloud. On November 11, 2000, the Sons of Union Veterans of the Civil War dedicated a memorial in Veterans' Memorial Park to the Grand Army of the Republic and "those Union veterans who in 1909 settled the 'Wonder City' of St. Cloud, Florida."

This is the dedication ceremony at the reburial of Lucius L. Mitchell in November 2000. The ceremony included a memorial service for the soldiers of St. Cloud. Those buried at Mount Peace include 364 Union soldiers and 2 Confederates.

Ronald H. Criswell, shown here in 2000, was the first commander of the Sons of Union Veterans of the Civil War, Lucius L. Mitchell Camp #4.

The Mount Peace Cemetery's monument, dedicated "To Our Unknown—1861–1865," is a few steps from the grave of Lucius L. Mitchell.

Visit us at
arcadiapublishing.com

CPSIA information can be obtained
at www.ICGtesting.com
Printed in the USA
LVHW060934120622
721080LV00007B/118